Practical Picture Restoration

Practical Picture Restoration

Peter Oldale

The Crowood Press

First published in 1999 by
The Crowood Press Ltd
Ramsbury, Marlborough
Wiltshire SN8 2HR

British Library Cataloguing-in-Publication Data
A catalogue record for this book is available from the British Library.

ISBN 1 86126 239 6

Illustration Acknowledgements
All photographs by Adrienne Oldale.

Typeset by Textype Typesetters, Cambridge
Printed and bound by Leo Paper Products, China.

CONTENTS

INTRODUCTION

We are surrounded by pictures, even if they are only last year's birthday or Christmas cards, holiday snapshots, calendars or free offers from petrol coupons. There are millions of prints, sketches, paintings by relatives, fingermarked school drawings, left-overs from abandoned evening classes, treasured mementoes of holidays and family visits, hanging on walls, propped up on mantelpieces, crushed in drawers or embedded in the grime of the attic. A few will be masterpieces, discovered by chance after lying unrecognized for years, and will make a fortune for their stunned owners. However, most will simply be pleasant pictures that we keep in our homes because we like them – the best reason of all for having pictures. Surprising numbers have actually passed down the generations. Pictures are often our most long-lasting family possessions; they survive long after other furnishings have been disposed of and replaced. Many, while not masterpieces, are pleasing minor works from the past and deserve a better life. For there is one strange thing about the pictures that we own . . . most of them are neglected. While furniture, curtains and carpets all receive attention, how many of us systematically check our pictures? They hang where we have become used to seeing them, fading because they are near bright light, becoming brown or spotted with acidity or damp, the varnish gradually darkening until the once-bright image is dimmed and obscured. For some, the day will come when the never-checked wire holding them up snaps and the whole thing shatters on the floor, the shards of glass ripping the picture surface. For those that remain, a gradual loss of attractiveness may bring forward the day of final disposal, either to a 'home clearance' buyer or to the depths of the rubbish bin.

Yet basic picture maintenance is easy, and this book aims to provide a practical guide to keeping your pictures safe, preventing or reducing the risk of defects. Moreover, many people do have a deep interest in paintings. They may own some that would benefit from more intensive care: cleaning, preserving and re-varnishing the actual paintwork of the pictures; remedying staining, cracking, flaking, fungus or insect attack; repairing and strengthening torn or perishing canvas or paper supports. Much of this work can be done at home, in fact most methods of picture care and restoration are similar to basic housework and home craftsmanship, requiring knowledge, care and patience. This book covers the knowledge . . . the other two are up to you! Of course we have to accept that, as with any craft, it takes a very high level of skill to reach the top of the restoration profession; people dealing with pictures priced in millions have to be knowledgeable about processes and acquire techniques that take years of study and experience. Also, they have access to materials and equipment that are far from the means of newcomers to the skill. Reading this book will not enable you to move into a top museum's restoration team or

set up next month as a professional picture restorer, but those at the top had to start somewhere!

You do not have to be a fully trained artist to use this book (it will help if you are, of course!). Every step is explained in basic detail, and all the specific terms that you must know are outlined as they are introduced. Other chapters describe how the various styles of pictures are made, how they deteriorate and the sort of repairs they may need. You will find lists of materials and tools needed when starting out and as you progress, as well as projects to practise on and methods to learn.

The field of painting is enormous and you will have your own particular interests. The book is arranged so that you can quickly find any information you need, and it helps you to discover what you simply *must* know – the value of a picture before you start any work on it! This is particularly important to restorers because if the painting turns out to be by a known artist it will probably answer many queries as to the materials and techniques used. To a newcomer it is even more important. If your junk-shop bargain is really an unknown Turner you would be well advised not to fiddle with it. Fortunately, you can discover a good deal about a picture through simple examination, using nothing more elaborate than a 4× magnifying glass (if you are seriously thinking of taking up restoration I suggest you acquire one of these right away). Some magnifiers have a battery and light and these are excellent for use in dark surroundings such as auction rooms, but do not rely on them for studio work as their light colour and intensity are inadequate. Nothing beats bright daylight and a plain magnifying glass for serious examination. In Chapter 3 I have set out a step-by-step guide to examining the majority of paintings and prints that you are likely to meet.

Over many years I have restored hundreds of pictures. Some have needed little more than a twenty-minute tidy-up; others have lost half their paint in fire or flood and have taken months of work. In size they have ranged from huge antique maps and full-length portraits to tiny ivory miniatures. Those of great financial value have usually been very old, and it is fascinating to know that you are dealing with works that once grew under the hand of a famous master. Most restored paintings were not in this class however, but were brought to me because of the pleasure they gave to their owners. The cost of their restoration may even have been greater than the picture's financial value, yet the owners felt it to be worthwhile. Unfortunately, there are many other interesting and attractive pictures that will never be professionally treated because, like other businesses, restorers have high costs, expensive premises and equipment, and these are reflected in their charges.

This book aims to equip a careful, practical and patient newcomer with the necessary skills to give paintings a new lease of life. You may well find the sheer pleasure of rescuing your special treasures or bringing back the beauty of some deteriorating work of art more than satisfying. You may even go further and as your experience, knowledge and skills increase, you will be able to undertake still more demanding work or eventually take up the profession yourself. Certainly, many a careful picture framer has gradually become competent at dealing with most of the troubles that affect his clients' pictures.

Finally, I hope you will find this book practical, interesting and worthy of a place in your studio.

Peter Oldale

— 1 —

RESTORATION

This is a book on picture restoration, but strangely enough there is no universally accepted meaning for this term in the art world. When clients bring in pictures for me to 'restore', I first have to find out exactly what they want. This may sound absurd, but think of the wonderfully kept and restored classic cars we see at rallies . . . all those ancient cars, gleaming from years of devotion. The usual aim of a car restorer is to remove every sign of wear and ageing, every trace of those years of traffic film, every tiny smear of dirt, rust and dust, though still using as many original parts as possible. In due course a restored car will look almost as good as new.

Now think of the world of antique furniture; the really valued pieces are those that certainly do not look new, indeed far from it. They have acquired over the years a worn 'patina' of old, well-rubbed polish, often very different from the original surface. Furniture restorers must work with immense care to keep all necessary restoration from altering this patina. Few clients want an antique table that looks as if it has arrived directly from Chippendale's workshop, showing no signs of age. Scuffing and scratches from ancient boots or spurs on the table's legs may actually increase its value, especially if they were King Charles' boots, and forgers spend months dirtying and knocking about their fake furniture in this way. But suppose that one leg of a genuine antique table was eaten up by woodworm. If this were not replaced, the table would be unusable. A suitable copy leg might be made, using the same kind of wood perhaps, but when this is done, should the replacement be 'distressed', even being beaten with chains, tumbled among stones, and stained in various ways before re-assembly, to make it look like the rest? Should it be left boldly new and obvious? Or something in between?

The same problems apply to pictures. Nearly all antique oil paintings have the craquelure described in detail in Chapter 7. This is a fine network of cracks all over the surface where the old oil has dried out and shrunk, splitting the paint into tiny islands. Craquelure is simply the result of the paint layer deteriorating; in principle it resembles rust on old iron. Some clients want their picture restored to the way it looked when the artist finished it, so that they can see the work as the artist intended they should. This is the 'showroom condition' of the classic car. So should a good restorer agree to join together or fill all those ancient cracks? Or should they press the client to follow the 'antique furniture' approach and leave the craquelure in place?

All varnishes applied to paintings, though transparent at first, gradually turn yellow and then brown, sometimes completely black. You can see this in many old, neglected paintings that hang in public buildings. The darkening alters the appearance of the picture to an amazing degree, and is very different from the orig-

inal studio colours. Again, this was not created by the artist, but by chemical changes in the paint and varnishes used in the work. Much of the varnishing will in fact have been applied many years after the painting was completed. Should we remove these dark coatings if we can? This could brighten up the painting's colours until they look almost like new, and it might well return the picture to the way the painter left it, so that a genuine Rembrandt portrait could look as though it had been collected from him yesterday. But would its owners really want this?

Many collectors would say that craquelure and slightly darkened varnish contribute, like the patina on old furniture, to the interest, appeal and atmosphere of the work, and will insist that the restorer keep all the discolourations, cracks and other changes caused by age, even though this means the appearance of a picture is very different from what the artist intended. The only work they want done is that necessary to prevent further change.

However, over hundreds of years many pictures have been severely damaged by deliberate or accidental tearing, puncturing, folding, scorching, burning, flaking and so on, and few clients believe that these disasters should be left unrepaired. They think of them as somehow different from the darkening of varnish and other changes that occur over time. But if we repair an old oil painting damaged like this, perhaps with holes smashed through and paint missing, what should we do about any areas that have vanished completely?

Leave plain wood or canvas in each gap?

Fill the gaps with some plain, evenly toned colour so that viewers can see which parts are original and which are repairs?

Fill the gaps with tones of grey painted roughly to indicate how the missing areas looked, so that the picture can be viewed more comfortably?

Fill the gaps with colours, reasonably close to those of the original so that from a distance the damage cannot be seen, though at close range it can be detected, and of course the craquelure will be missing in the patches? Or should we apply exact colouration, reproducing the cracks of the craquelure and any remains of discoloured varnish so that even at close range the repair cannot be seen?

I have offered these alternatives, but

Fig 1 Plain wood showing on a damaged wooden panel. This needs 'inpainting', but the colours need careful consideration.

Fig 2 Here the damage is simply covered with plain grey protective paint.

Fig 3 Here the damage has been painted in grey tones to indicate the missing image and improve the viewing appearance.

Fig 4 Detailed colours to resemble the original have been used here, but not all owners require this. In all cases any added paint must be technically distinguishable from the original.

11

there is no hard and fast rule about which is best. Indeed, the above are problems often discussed by restorers and art specialists of all kinds, often resulting in furious rows! When advising clients about these problems and choices there are four main aspects to consider, set out below, but I do not pretend to know the order of importance in which they should be arranged.

How a picture should be treated depends on:

- the financial value of the picture
- the historical value of the picture
- the aesthetic beauty of the picture
- the wishes and needs of its owner.

FINANCIAL VALUE

When an unfamiliar picture is brought to my studio I go through the checklist set out in Chapter 4. This is important, however the value of a picture can vary, even over short periods. What most wealthy buyers are looking for at any one time is a matter of fad and fashion, as well as their judgement as to which artists' works are rising in value and which falling. An artist may be referred to as becoming 'more collectable'. This does not mean that he or she is now thought to be a better artist, simply that the auction houses have recently managed to get more money for his or her pictures than they did last year.

The owner of the painting will have to allow for these factors when estimating the value of a picture after restoration, and then decide whether the work makes financial sense. At an expensive level, pictures that look their age are more likely to fetch high prices, provided they are not obviously damaged. Completely removing old varnish to retrieve the original colours, therefore, is not usually required. I have

often been asked to be 'discreet' in the way I restore a picture, leaving at least some trace of varnish in place. Re-painting and repairs, if done at all, should preferably appear as if they were done many years ago, so attracting the respectability of age.

Very high prices arise from state or wealthy private collections whose purchasing agents are spending somebody else's money. Such collectors often buy for reasons of prestige, and nobody really dare make too radical a choice in restoration as there is always somebody else to disagree and a comfortable job might be at risk. The purchasing galleries frequently opt for the safe decision of keeping the picture as it is, warts and all, taking only such steps as are necessary to prevent further change. In my view this is sensible with irreplaceable historical masterpieces. The risk of something going wrong in restoration (and there *is* always a risk) is simply too great.

However, at a slightly lower (yet still high) price level, dealers supplying private collectors come into their own. The restoration choices then depend on the dealers' views of the type of picture for which their clients will pay most. This is still not usually a completely 'new' appearance. The impression of such a restoration is that it somehow appears spurious; it is known to be old, but does not look old. Actual damage, which potential buyers might see as requiring expensive essential repairs, must be carried out, but in a manner that does not impinge visually upon the age of the work. Really dark varnish that obscures the subject must be removed, but may be replaced by a varnish that has been slightly dulled, or even discreetly coloured. The pictures have to look like old masters, because many buyers want to display them (in a suitably genteel way, of course) as an indication of

their own culture and wealth.

Owners, as opposed to dealers, of middle- or low-priced pictures are most likely to require a fairly extensive return to the artist's original. They are nearly always amazed and delighted when a blackened, gloomy-looking Victorian evening scene is transformed into a pleasing summer landscape. Their pictures are for looking at, for their own pleasure – certainly the soundest reason for buying a painting, and presumably what the artist actually intended.

HISTORICAL VALUE

This is primarily a matter of the name of the artist, and whether the picture is genuine. In establishing the way in which painting as an art or craft has grown over the centuries we usually follow changes in the work of contemporary artists, the way they were influenced by others or by technical changes, and the influences they may themselves have introduced.

When restoring such important pictures, it is essential to ensure that future owners and restorers can be certain which parts are original and which are additions or repairs. Much of our knowledge of art history is based on the choice of pigments by any particular artist. One may introduce a new colour or try out a new medium, and there must be no doubt as to which paint strokes are his. To provide for this, any necessary inpainting (the replacement of patches of missing paint) must be done in an identifiably different way. In common with most professional restorers I nearly always use a different medium from the original for repairs: pastel on water-colours, water-colours on prints, oils on acrylics, acrylics or water-colours on oils, and so on. When I use acrylic to inpaint oils, for example, it stays in place reasonably well to enable enjoyable viewing, but can easily be removed later without damage to the underlying paint and, of course, acrylic medium is completely distinct and identifiable. Do not imagine, though, that you will be able to tell it is acrylic by casual inspection; the pigments are the same and the work can, if required, be made completely indistinguishable.

AESTHETIC VALUE

There has never been any general agreement on what makes a picture beautiful or significant in some other way. The views of leading individuals in the art world are valueless, indeed more nonsense is talked and written on this subject than on any other aspect of art. Pictures once acclaimed by nationally renowned experts as the height of beauty are later derided; those then preferred are later discarded as awful. Later still, the first return to favour and so the cycle goes on.

In spite of this, it is easy to discover whether a particular picture is beautiful – simply look at it. If you think it's beautiful, it is; if you don't think it's beautiful, it isn't. Discovering whether somebody else thinks it is beautiful is equally easy, and done in the same way. Of course the two views may not be the same, but that does not matter. Beauty is an inner sensation that may or may not be stirred when looking at a picture. A person who claims that a picture is inherently beautiful or meaningful is often trying to sell it or, even more commonly, to demonstrate that they are fortunate in being more sensitive and discerning than the rest of humanity.

THE WISHES AND NEEDS OF THE OWNER

It is sometimes possible and always desirable to discover what it is about their picture that a particular client finds attractive. If, for example, they love the 'golden glow' of an oil landscape, it might be advisable not to remove all the old, deteriorating varnish that may be causing this effect. Whether you should offer to remove the old and apply a fresh varnish that is itself slightly coloured, as has been done often in the past, is a point you must decide for yourself. This would certainly be a profound and deliberate change to the original artist's work, since such a varnish would really be a coloured glaze. I would be reluctant to do this myself, particularly if there was any chance that the work or the artist were of significance, and would always use a glaze that was easily removable later, adding a note to this effect on my invoice and naming the solvent that should be used for its removal.

Perhaps it is the intricate details that seem to be the attraction, and in this case I would be able to assure the client that these would be much clarified and sharpened by removing the obscuring varnish and applying a clear replacement.

Water-colours, which are not usually varnished, do not darken but often suffer from fading. It is possible to enhance weak, faded colours to some extent using pastel, but it must be established with the client that the change would be welcomed. Many people associate water-colour with the faded tints so many now display, and feel that they lose their atmosphere if there is any intensification of colour or contrast, even if this is as the artist originally produced them. The work should only be done when the original colours are known; these can be seen in any unfaded areas which may have been shielded from light by frames or mounts. This is a very difficult job to do successfully, however.

Since any client may find something beautiful that I do not, I try to restore the picture as well as I can in such a way that they continue to receive the feeling they need. If this involves their insisting on leaving some yellowed varnish, or undetectably re-painting part of an apple that has fallen off the picture, then I do so, but I also make clear whether it ought not to be done on technical grounds, where further deterioration can be expected, and indeed how the financial value of the picture could be reduced or enhanced by the work.

There are also many diffident clients who, far from pressing their views on you, clearly feel oppressed by the fear of liking the wrong pictures! They may even apologize for the picture they are showing me, saying perhaps, 'I realize it is not a good picture, but I like it'. I find out first what it is that worries them about the picture; after all, they would not have brought it in for restoration unless they thought something needed attention. Then, unless the work is of historic importance (in which case they would be well advised to sell it), I discover what it is about the picture they like, and restore it so that it is improved in their eyes and for their needs. If you make a picture more beautiful in the eyes of its owner, you have succeeded, whatever any art critic may say.

— 2 —

VITAL TERMINOLOGY

Artists and restorers use many specific terms to describe their materials and methods, as this helps to avoid what may be very expensive misunderstandings. Such terms are vital to all those involved with pictures and you will need to understand exactly what each one means. The first three are: pigments, mediums and diluents.

PIGMENTS

These are the actual colours used to make paints, and consist of dry powders ground very finely from natural or artificial materials such as clays, minerals, metallic-based chemicals and so on.

In the past, pigments were bought in glass tubes to be hand ground into a bottle of linseed oil. This usually left the paint particles looking distinctly coarse under the microscope, unlike modern machine-ground paint.

Occasionally a desirable coloured material is only available as a liquid. In this case a colourless powder is soaked in the colour, and this powder then becomes known as a 'lake' (crimson lake is the most well known). Some pigment powders are very powerful and hard to use as paint because they colour too strongly. These may have a transparent or colourless powder 'extender' added to reduce their strength to a workable degree. Very cheap paints may have a large amount of extender added even to normal pigments, which reduces costs but gives a weaker colour.

MEDIUMS

The pigment powders need a 'glue' to enable them to stick to the picture paper or canvas, and these glues are called mediums. Many materials have been tried over the centuries. The medium for water-colour is usually gum arabic, a water-soluble glue, though other weak glues have been tried. Since water-colour is a very thin liquid, when applied to paper it soaks in and the pigment powder becomes embedded in the paper fibres. It then remains in place easily, even with a weak medium. In fact, the paint layer is often so thin that light falls through it and is then reflected back from the white paper beneath, giving the traditional glow of 'transparent' water-colour.

Gouache is a similar water-colour made thicker and more opaque with chalk, giving a paint that lies on the surface as a distinct layer rather than soaking in, and which does not allow so much light to pass through. Gouache medium is frequently gum arabic, perhaps with honey and glycerine added.

The mediums for oil painting are nearly always linseed oil and poppy oil, though walnut oil and others are used occasionally. These oils act as glues because they set gradually over several months to grip the embedded pigments in a leathery, slightly

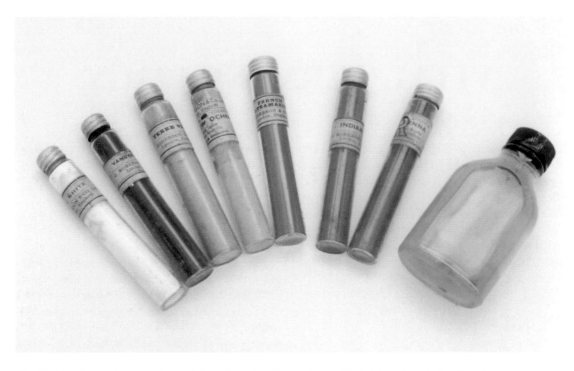

Fig 5 All pigments are coloured powders, traditionally supplied in glass tubes for the artist to grind into a linseed oil medium.

flexible skin. They do not fully dry, though they soon feel dry to the touch, but change chemically and indeed continue to do so for years. At first, hardened linseed and poppy oils are a pale yellow, but over time they tend to darken to a deeper yellow, especially if the application of the paint has not been to the highest standard. This can slightly change the appearance of paintings. Historically, many other mixed mediums have been tried, sometimes with disastrous results as with a mixture of varnish and linseed oil called Megilp, widely used in the last century. These mediums now present serious problems to any restorer who has to tackle them.

Art suppliers also stock mixed mediums for oils, which are mainly used in making thin, translucent 'glazes', like lightly coloured varnishes. They are intended to give faint tinges of colour over existing paint. Such thin coatings also create restoration problems, especially as many famous artists used them extensively, sometimes with ten or more applications one on top of another!

The medium for acrylics is simply called acrylic medium, a milky, rapid-drying water-based emulsion that changes into a clear, tough, flexible and long-lasting skin in which the pigments are embedded, and which dries with an eggshell finish. It does not seem to alter in colour with age in the manner of linseed and poppy oils, but it has only been in use for fifty years or so (no time at all in art terms!) and changes may appear later. The medium can be bought separately from the paint in three forms – gloss medium that dries rather shinier than the normal paint, matt medi-

um that helps the paints dry flat, and retarder medium that slows down the rapid drying of acrylic.

The traditional tempera medium was fresh egg yolk. Pigments were ground into a water paste that was mixed with yolk each day as required. A restorer is unlikely to come across many genuinely old tempera paintings, and as they are likely to be valuable you would be well advised not to use one for practice. Art shops now sell commercial paints in the tempera family that are water-based, some with oil content, or other proprietary mediums. Paintings made with these should be approached with caution, treating them initially as water-colours.

DILUENTS

Paints with the correct amount of medium may still be too thick to work with easily; they may even be solid, like pans of water-colour. A diluent is a liquid that thins paint down as required. The important thing about diluents is that they do not remain in the picture, but evaporate, leaving only the medium and the pigments behind. If too much diluent is used, however, this can spread out the paint film so much that it produces a thin, badly adhering paint; during restoration, this weak sort of film may be easily damaged.

The usual oil diluents are turpentine and white spirit. Both are equally effective but have a different smell. Turpentine can cause health problems in rare cases.

The water-colour and gouache diluent is of course water. Water is also used as the acrylic diluent.

There are many other new terms that you will encounter as you increase in skill, and I will explain these as appropriate, but the three above are essential and form the technical basis for all painting. In fact, I recommend that the words '*Paint is a powder, glued in place by a medium, applied thinned down with a diluent that evaporates completely*', be cut in stone wherever artists or restorers work!

— 3 —

EXAMINING PICTURES

All initial decisions taken in picture care and restoration are based on the way the picture was made. The first thing that any restorer does is to identify the medium used, and with practice this is relatively easy in most cases. However, the penalty for a mistake can be high, so it is important to be systematic.

Set out below is a step-by-step approach to examining pictures which should prove successful in the majority of cases. Like most, if not all restorers however, I have myself been embarrassingly wrong in my first identification of the medium and age of a painting seen for the first time. For example, distinguishing varnished acrylics from varnished oils is often tricky until you actually get to work, while many coloured prints look very similar to original watercolours when still in their frames. Fortunately, the methods used at the start of a restoration soon lead to the evidence that reveals what the medium actually is, so no harm need be done.

Your aim is to discover what sort of picture you are studying, whether it is a print or

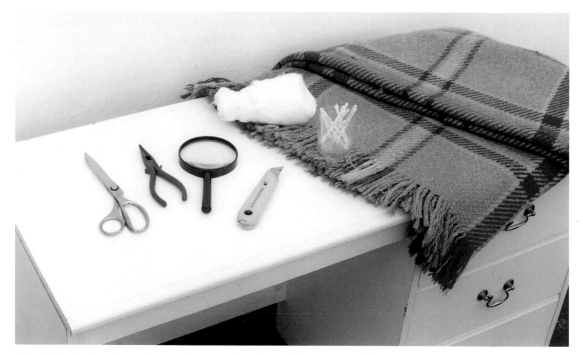

Fig 6 Tools for picture inspection are simple and inexpensive, but do get a good, large magnifier.

an original, and if it is an original, in what medium, for example oils or water-colour.

I have listed a series of questions to ask yourself; use a notebook to record the answers and other details as you go. You will also need some cotton wool or cotton buds on sticks, a pair of small pliers or pincers, a razor tool, scissors, and a table covered with a thick, doubled blanket or similar padding. You can add other tools discussed later in the book as you progress.

Your main requirement is some means of magnification. Eventually you will end up with a number of these, but initially a plain magnifying glass on a handle is vital. There is a definite technique to using one: hold it close to your face, with your thumb touching your nose, and draw the picture up towards you. Some people use the 'loupe', a single lens inserted in the eye. This works well for close study, but I find I can never hold it in my eye!

For working use, a cheap plastic book sheet magnifier, preferably raised on an improvised wooden stand, is very convenient.

Even better, but rather expensive, is a set of magnifiers on a headband, giving much larger magnification, ideal for precision work.

Up the magnification scale still further, but not as costly as the headband, is a 30x hand microscope with a built-in light, especially useful for the detailed study of prints.

Finally, the ultimate item for professional study is a compound microscope capable of resolving even the textures of papers and pigments.

IS/WAS THE PICTURE FRAMED WITH GLASS?

If the picture is framed with glass, lay it face down on the blanket. If, however, the

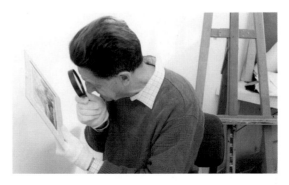

Fig 7 In use, hold the glass close and bring the picture up into focus.

Fig 8 A plastic book-reader magnifier, raised on a simple frame, is a useful working aid.

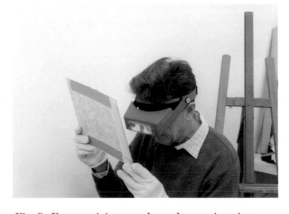

Fig 9 For precision work and examination, binocular headbands are ideal. They are available in different powers of lens.

19

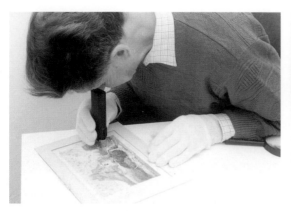

Fig 10 A pocket microscope give thirty times magnification with a built-in light.

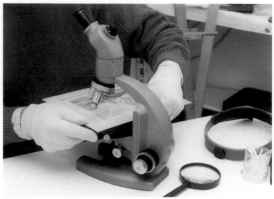

Fig 11 For serious study of paint films a compound microscope is essential, but expensive. (Small, children's types are of little use.)

glass is broken, remove any loose pieces now. If some shards remain tightly held, slide thick paper slips under these to protect the picture from scratching.

Remove the hanger cord at one end, but leave the hanger screw rings unless these are obviously rusted away and need replacing. Re-fixing new loops in old, thin frames can split the wood.

The entire back will probably be covered in paper or card, perhaps with adhesive tape round the edges. Cut this through near the frame, but note and save carefully any framers' or other marks.

Peeling away the tape will expose the pins, nails, diamond or triangular brads holding the picture to the frame.

Remove the fixings, saving unrusted ones for re-use. Work cautiously; the frame material will probably be thin, and undue force may tear the corners apart. Look out for any pieces of broken glass lodged in the card or frame.

Lift the whole picture and gently free the frame by pressing down evenly along one side with the thumbs while lifting undamaged glass and backing with the fingers from underneath. *Do not apply strong force* or the glass may shatter and cut you (it could be held by an unnoticed nail).

Try to bring out the whole interior, glass, mount, picture and backing card all together. Lay it face-up on the blanket and set the frame and glass aside.

The picture may have a bevel-edged or other mount (known in the USA as 'mat') in front of the picture. It will probably be attached to the picture by tapes or hinges of pasted paper. Remove or cut the tape to free the picture. Keep the mount for the moment but in general do not re-use it; old card is always suspect in framing. Sometimes the picture itself is glued down to the backing card. If so, do not remove it until you have finished identifying the picture.

Once the picture has been dismantled from the frame, look at the picture but do not press on its surface.

- Is the painting on paper alone, or on paper glued to card, board or canvas? You can check by finding edges of the paper. The texture of any board or canvas may show through the paper glued

Fig 12 *Rest any glazed picture on padding during dismantling, first removing any broken glass.*

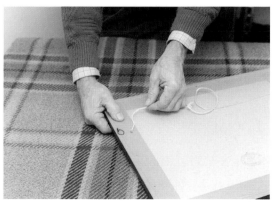

Fig 13 *Remove the cord carefully, checking the hooks' security for reassembly.*

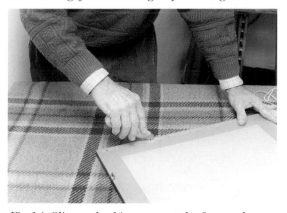

Fig 14 *Slit any backing tape at the frame edge . . .*

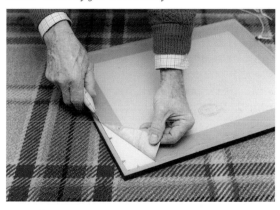

Fig 15 *. . . and peel the tapes away all round.*

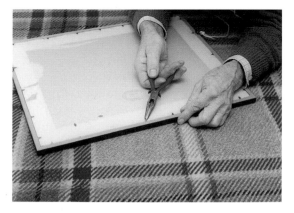

Fig 16 *Take care when removing fixings not to crack thin framing wood.*

Fig 17 *Finally lift out the glass, mount, picture and backing card together.*

Fig 18 Separate the frame parts and take out the picture with its attached mount, if any.

Fig 19 Peel away any loose paper tapes holding the picture to its mount. Never apply water to soften the gum.

to it, as most are made by applying paper under pressure. If it is paper, look at the light reflected from the picture surface.

- Is the paper surface perfectly flat, smooth and faintly glossy, even shiny, all over the picture area and right out to the paper edges? This is almost certainly a print of some sort. Very few actual paintings have an appearance like this, without any trace of surface brush marks. Even thin water-colour marks will reflect light differently, and these are rarely done on paper with even a light gloss.
- Are there any marks on the actual picture surface, such as printed numbers, publishers' names, lines, regularly shaped coloured patches, or hand-written notations, for example '25/300'? If so, it is definitely a print. The marks help to check colouring and the alignment of the printing press, while '25/300' means that this is the 25th copy of a print-run totalling 300.

Look at the picture face through your magnifier.

- Is the picture made up entirely of many

very fine dots and lines, often with areas of regular texturing, but no colours? If so, again it is almost certainly a print. The patterns created by the marks indicate the way in which the printing plate was produced by engraving, etching, lithography and so on.

The only other possibility is that it is an ink drawing. Under high magnification you will be able to see how some lines actually cross each other, evidence that they were drawn separately.

- Is the picture made up of dots and lines, but with transparent coloured marks through which these show?

This is probably a hand-coloured print. The coloured parts will usually be water-colour. It is also just possible that it is a combination print made by two different printing means, superimposed one on top of another. Powerful magnification will disclose the truth but is unnecessary as the cleaning methods would be similar for each.

- If the picture is coloured, under high

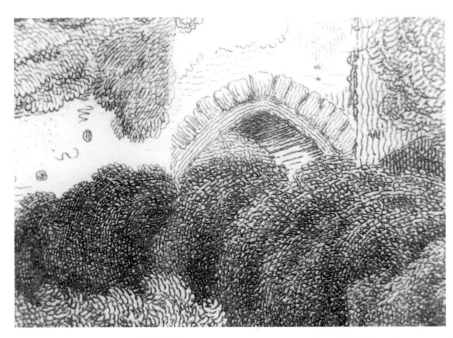

Fig 20 In close-up, many antique paper pictures have black lines in complex patterns like this print.

Fig 21 If in a black line picture the finelines can be seen to cross each other, this indicates an ink pen drawing.

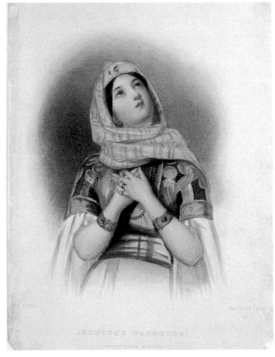

Fig 22 If the picture has a black background drawing with areas of plain colour, it could be a hand-coloured print like this Asiatic woman.

23

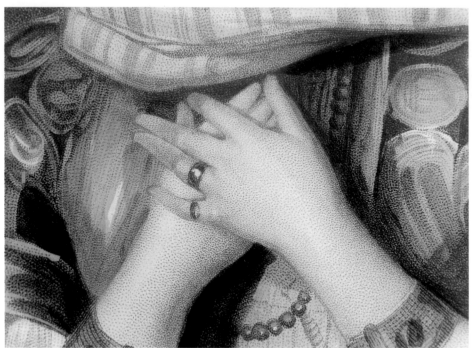

Fig 23 The crossed hands shown in close up indicate the astonishing detail that can be achieved in etchings and engravings.

Fig 24 The tooled surface of the printing block is often scraped down to produce graded areas of light and shade as shown in this face.

Fig 25 Thousands of minute dots in four colours indicate a modern colour print.

magnification does it consist of thousands of regularly spaced tiny spots of three colours and black? If so, this is certainly a print, created using a system that produces the appearance of multiple colours even though the four inks are not actually mixed. This is the most common method of modern full-colour printing.

- Is the picture coloured, with the ink appearing rather spattered, particularly the blacks? If so, this is a colour photocopy print.
- Does the picture have the appearance of a print, but its surface appears to have been covered with clear or faintly yellow varnish, perhaps with visible brushstrokes at random, only roughly

Fig 26 Irregularly spattered dots of colour and black indicate a modern photocopy.

25

Fig 27 Various varnish treatments of prints are seen, emulating the appearance of oil paintings. Most are very hard to restore.

Fig 28 Coloured prints may look quite like paintings at a glance . . .

Fig 29 . . . but magnified patches of thick paint show that this is a print with applied surface colour.

Fig 30 If in doubt, look at the print first in normal light . . .

Fig 31 . . .followed by viewing in ultra-violet light to bring out areas of paint clearly. Paint retouchings on oil paintings can often be intensified as well.

corresponding with the shapes and lines of the picture? This is a 'varnished' or 'textured' print which has been coated like this, or otherwise treated to make it look older or to resemble an original painting when seen from a distance.

A smoothly finished, overall brown-gold tinged colour print is often referred to as an 'oleograph'. It is not possible to remove the varnish or clean such prints effectively without damaging them.

- Does the picture have the marks indicating a print, as outlined, but with some thick surface brushstrokes that appear to be of ordinary paint?

If so, this is probably a painted print, in which dabs or layers of coloured paint and varnish are applied to a printed surface to mimic an original painting. It is sometimes hard to see the underlying print surface, even through a magnifier.

One instrument that can help, and will also often pick out re-touchings on oil paintings, is an ultra-violet light. Seen in normal light, additions can be difficult to pick out.

Fig 32 A powdery surface being shed inside the frame indicates that this portrait is in pastel. Treat it with great care!

Under ultra-violet light the surface paint becomes much more visible. If you are still in doubt, any treatment should start with the assumption that the picture is a water-colour original on paper.

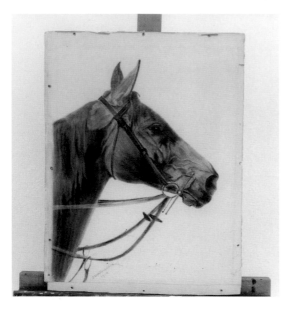

Fig 33 Not all charcoal works are merely sketches. This horse head has an almost photographic realism.

If the paper is not yet identified as a print, and the paper surface is matt, feel this surface using your fingertips. Start near one edge but do not press firmly or rub on picture areas until you are sure the colours are not loose and powdery.

- Does the surface of the picture have a matt, powdery texture, perhaps with indentations or low ridges, especially compared to the plain paper margins, and does loose powder tend to sift from the surface, perhaps into the rebates of the frame, or mark your fingers if you touch the surface? If so, it is most likely to be a pastel (as the pastel portrait), or a chalk or charcoal drawing (as the horse's head). However, it could be water-colour or powder paint in very poor condition so *do not rub further!* Set the picture aside and see that the surface is protected. Such pictures are very hard to restore or

clean, particularly for the inexperienced, without doing damage, even if they are supposed to have been 'fixed'.

- Does the picture show no sign of printing patterns, but has a firm surface, even and mainly smooth-textured under your fingertips, and with definite thin, added layers or brush marks?

Using a small cotton bud, moisten a tiny portion of colour that preferably lies off the picture area, behind the mount or frame edge.

- Is colour removed or transferred to the cotton? If so, it is almost certainly water-colour or gouache.

Fig 34 Thin paintings are usually prints or water colour.

Fig 35 Moistening the edges with water can test whether colour is removed. If so, it is water paint.

28

Fig 36 Water colours may be freely painted, with white paper showing through . . .

Fig 37 . . . or detailed and solidly coated, indicating heavily-applied water colour or Gouache.

- Is the paintwork so thin that you can see the paper clearly in gaps between the brushstrokes; are the whites in the picture plain paper, and can you also see the texture of the paper breaking through the coloured strokes? If so, it is transparent water-colour.
- Does the paint, though thin, completely hide the paper, and do the whites seem to be actual paint rather than unmarked paper? If so, it is gouache (opaque water-colour) or normal water-colour applied thickly. Often, paintings mainly in gouache have transparent washes in places.

There are exceptions, however. Some transparent water-colour artists use white gouache paint strokes for emphasis in places; this is

called body colour, but the rest of the paint-work remains transparent, as seen in this Japanese-style picture. Note that this sort of painting, especially if painted on or mounted in silk, is often fragile ink and water-colour, requiring exceptional care when cleaning.

- Is the colour unaffected by moistening, even when quite prolonged, with no colour coming off on to the cotton?

If so, it is possibly thinly painted acrylic which, once dried, is not soluble in water, but looks rather like true water-colour.

Fig 38 This Japanese flower painting has had its whites intensified by 'heightening'.

Again, there are exceptions. Unusual mediums such as egg tempera or alkyd paints are occasionally found on paper. These also do not always release colour. If in doubt, treat it as transparent water-colour.

- Is the paper surface entirely covered with paint in clear colours and detectable layers, with some visible brush marks? Rub the surface with water-moistened cotton as described.
- Does the paint resist rubbing and lose no colour? If so, it is almost certainly normal acrylic paint (as opposed to thin acrylic that looks like water-colour, as described). There is, however, also the possibility that it may be an original oil painting on paper. These are often amateur paintings, but some professionals occasionally make pre-liminary sketches, or even complete works on paper. Turn the paper over as the back will often show stains where the oil has penetrated. The face may also show signs of varnish (acrylics on paper are rarely var-nished). If it is oil, then tests done when beginning restoration will confirm this.

Fig 40 A resistant paint with surface texture is almost sure to be normal acrylic, but occasionally may be oils.

Fig 39 Non-soluble paint may well be thin acrylic, that can look very like true water colour.

IS THE PICTURE FRAMED WITHOUT GLASS?

Place the picture face-down on the blanket.

You can tell a lot about a painting before you even see it. This large frame, solidly made, obviously dates before the 1950s (when acrylics first came into use), so the picture itself will almost certainly be in oils. Its dark and dusty canvas confirms this, and because it is a fine woven, reasonably high-quality material, it is likely to have been made by a professional painter of the time. It may be held in place by many means, some very crude. Note any written marks on the frame or canvas.

Study the back carefully. Remove the hanger cord and sealing tapes. You will see that the stretchers are fine-quality, straight-grained wood, another indication that it was professionally painted.

The crudest fixing method is the most common – rusty nails, driven into the picture frame, perhaps through any stretchers and possibly through the painting too, or bent over behind the stretchers.

Draw the nails out using small pincers or pliers, and gradual leverage. With smaller frames, insert a flat metal tool beneath the pincers to avoid damage. In rare cases, corner pieces of brass or wood may be fastened to the frame with screws. Remove the screws cautiously; they often shear off and the screwdriver can then slip and pierce the canvas. If they are very tight, first twist as if tightening them very slightly before starting to unscrew them.

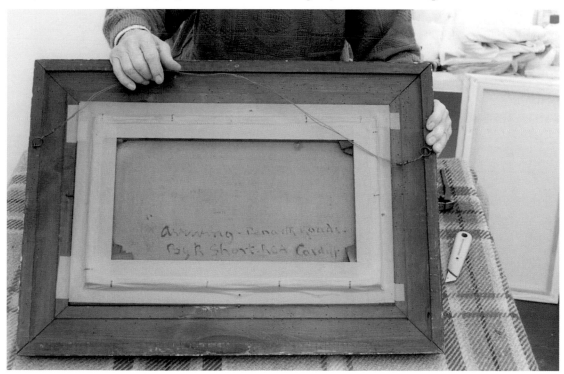

Fig 41 This painting on fine grade canvas is almost certainly older than fifty years, so cannot be acrylic. Photograph the writing!

This breaks the hold of the screw on the wood (sometimes the screw slot is damaged under this pressure, but at least you may still be able to turn it the other way). This is a very sound method of fixing, so re-use the corner pieces, replacing all the screws with new brass ones; *never* use steel.

Modern fixings are often bronze or copper-coloured Z-shaped clips, with their sharpened ends driven into the rear of the stretchers or board and the inside of the picture frame. These are strong yet flexible fixings and prise out easily.

Fold the clips well back before lifting the picture out or their tips may scratch the paint. If they are sound, and the picture frame needs no work, you can leave them in place for later re-fitting, simply by hammering. If any break, you can buy them from framing shops

In many cases there will be little wedges or discs of cork around the picture to space it away from the frame and allow for expansion. Keep these for later use.

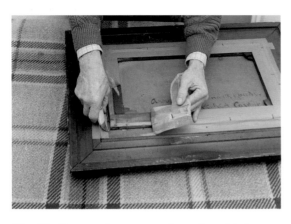

Fig 42 Remove hanger cords and seal tapes, exposing the good quality stretchers.

Fig 43 Crude, rusty nailing is quite common, even in valuable works.

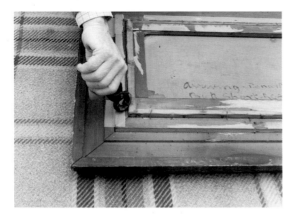

Fig 44 Lever the nails free, and remove them completely.

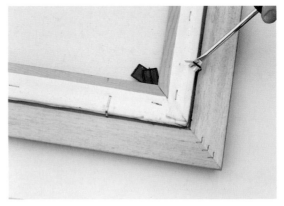

Fig 45 More modern pictures are held with Z clips. Prise these free with a tack-lifter tool and save them for re-use. . . .

Other picture frames may be covered in paper or card. This is a good yet rare framing practice with unglazed frames. The cover may have vent holes. If it is paper-covered, cut it all away but save any framers' labels or notes.

If it is card-covered, remove the card carefully for possible re-use; it will probably be held on by staples or tacks. However, note this bright orange card, often found in old frames. It will release a powerful yellow dye if wetted, and that can ruin your picture. In this case, throw it away.

• Is the actual picture on paper? If the picture is on paper mounted on to board or canvas (paper edges are always easy to find), check whether it is a print or acrylic by going through the procedure described earlier.
• Is the actual picture on something other than paper?
• If so, is the picture on canvas or other cloth stretched over a wooden frame?
• If so, is the canvas heavy, dark-coloured, fine-woven linen, and are the stretchers straight-grained, from cleanly planed timber, finished with perfect joints and wedges carefully cut and fitted?
• Are the securing tacks deeply rusted in

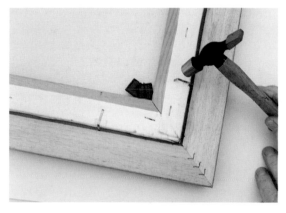

Fig 46 . . . they can be hammered into frame and stretcher wood without splitting it.

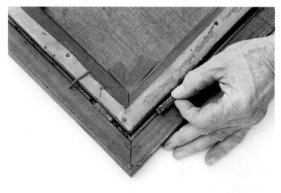

Fig 47 Cork spacers between stretcher and frame allow the picture to expand.

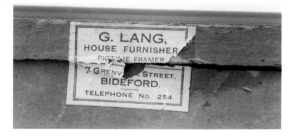

Fig 48 Framers' labels and marks must be preserved. They can be important in identification.

Fig 49 Beware yellow card as a backing! If wetted it can stain pictures badly.

Fig 50 This old oil on canvas of an Arab has been stuck to stiff board, a process called 'laying down'

Fig 51 Its edges are separating and the canvas is becoming loose.

Fig 52 Checking in bright sunlight is ideal. It makes it easier to see old restorations and possible forgery.

or largely discoloured, greenish brass, copper, or tintacks? This is probably an old canvas and painting and will almost certainly be in oils. Such careful manufacture indicates a professional painter using fine materials, and it may be valuable. Do not do any work on it until its origin has been checked.

● Is the picture on canvas that itself appears to be stuck down on to a second canvas which in turn is stretched over a wooden frame?

This is what used to be called a re-lined painting, now simply called a lined painting. Many old paintings have had their original canvas reinforced in this way, and the new lining canvas may be a different weight and colour from the original. The picture will almost always be in oils. Instead of being attached to new canvas it may, as with this portrait of an Arab, be glued down to a rigid board. This is called 'laying down', a process that may reduce the value of the picture and makes later maintenance of the original canvas impossible.

Check the canvas or board edges, which may be separating with age. Re-lining and laying down have always been expensive processes so it shows that at some time the picture was thought to be valuable. Again, do not do any work on it until this has been checked.

Note that genuinely old canvases are sometimes re-used and overpainted in oils, producing an old-looking forgery. Traces of the earlier picture are sometimes visible in the background, especially in strong side-light or brilliant sunshine. Such forgers may even line or lay down their pictures to make them appear genuine.

● Is the painting canvas medium or heavy, perhaps darkish and of medium weave,

on straight-grained wooden stretchers in sound timber, well finished with flat, triangular wooden wedges in the corners, and the canvas held in place by tacks that are only lightly rusted? This canvas may be much younger, as will be the painting, although it is still most likely to be in oils. Look at any written dates, but do not rely on them as proof of the artist. Most have been added by framers – or optimists!

- Is the canvas medium or light thickness white cotton on pine or deal stretchers, often with irregular grain or knots, with staples securing the canvas edges and perhaps with plastic wedges in the corners? If so, the stretchers are fairly new, as is probably the painting. An old painting may have been re-stretched, but the poorer the wood of the stretchers, the less valuable the picture is likely to be. The paint may be either oil or acrylic. Look carefully round the turned-over edge of the canvas. If the canvas is definitely white and if its fastenings are all staples or obviously new tacks, the picture is almost certainly recent. However, if the canvas is brownish, with the edges between the staples torn or perforated with brown and rusty old nail holes, this indicates an older painting that has had its stretchers replaced.

Note that many thousands of mass-produced paintings on canvas have been imported in recent years, particularly from the Far East. They often have very flexible oil or acrylic paint on clean, white cotton canvas stapled on wedged, expandable stretchers. Some, however, have much thinner canvas stapled on nailed together, non-expandable frames. Though most are crude, in some cases the original painting from which these multiple copies are made is quite pleasing. Any signatures they bear can be ignored; they are usually taken from telephone directories! Identical pictures are sold all over the world, as if by local artists, or traded by so-called 'students' from door to door. Many holiday resorts with an art tradition have shops full of these, sometimes with a local 'artist' sitting in front of a half-completed example. It is possible in the trade to order these paintings in bulk by sending photos of local viewpoints and buildings. Their style is easy to identify within the art world and they have no value beyond their appearance, however they can give a great deal of

Fig 53 Be wary of dates written on the picture rear; these are rarely applied by the artist. Record them nonetheless.

Fig 54 New canvases are usually brightly white and may have plastic wedges. Few will be valuable.

Fig 55 This acrylic abstract is painted on hardboard that makes a surprisingly good support for its low cost. The value of such works depends on the artist.

pleasure at very low cost. I mention these in case you may take a painting for valuation and find it unexpectedly dismissed as worthless. This is incorrect. The value of a picture is in your emotional response to it.

- Is the picture on thin canvas glued to a support of stiff card or hardboard? If so, this may be in oils or acrylics and is most likely to be an amateur work. However, in modern times even well-known artists sometimes use materials of very low quality.

- Is the picture painted directly on to a skilfully constructed board of solid timber, perhaps with embedded reinforcements and with an aged appearance? If so, this is likely to be old, the paint will be oils or tempera and it is

likely to be valuable. Do not do any work on it until this has been ascertained.

Note that egg tempera usually has distinctive, small brushstrokes with sharp clear, matt colours. The surface will be nearly smooth. You are unlikely to come across many of these; the work of restoration presents special problems and is unsuitable for inexperienced workers.

- Is the picture painted directly on to a modern process board such as hardboard or plywood? If so, the painting is likely to be recent and may be in oils or acrylics.

The ease of creating heavy impasto (*see* Chapter 7) in acrylics makes a rough surface common. Varnishing is unnecessary

and flaking is not usually seen.

A few artists have used metal supports, almost always with oils, but the paint may have been specially formulated. These are now rare. Some modern works have been done on aluminimum and other metals. Information about the treatment of such pictures is sparse. Occasionally artists have used ordinary cardboard as support material. These pictures are frequently in poor condition and are actually quite difficult to restore because of the fragile nature of

Fig 56 The acrylic makes a heavy texture 'impasto' easily. Such thick clayers are much tougher than oils.

Fig 57 It is often impossible to tell at sight whether a varnished canvas is in oils or acrylics. This one has acrylic underpainting finished in oils and varnish.

the support. All of these should be avoided until you gain experience.

TELLING THE DIFFERENCE BETWEEN OILS AND ACRYLICS

Oils and acrylics are quite different paints, but when varnished, either on canvas or boards, it may be impossible to tell them apart with the eye alone. The pigments are identical, and although the dried acrylic medium gives an eggshell appearance (similar to domestic emulsion paint), this is no longer visible when covered with artists' varnish. One point to remember is that oil paintings are still more common than acrylics if the subject is traditional.

Acrylics have a solid, leathery consistency when dry, an eggshell surface, and are usually completely homogeneous throughout their thickness.

Oils tend to be more glossy when fresh, duller when old, distinctly 'layered' in structure, and less cohesive when mature. Recently painted oils can sometimes be identified by sniffing the rear of the canvas, where the very faint smell of linseed may still be detected. You can try cautiously flexing the extreme edge of the paint layer between your fingers. If the paint appears dry and flaky, remaining matt even when rubbed with the fingertips, shows traces of varnish, and the painting as a whole has many fine, random cracks, this indicates oils painted some years earlier. The apparent age of the canvas may also help, as the older it is, the less likely the picture is to be acrylics.

If the paint has an eggshell surface, however, is tough, flexes easily when thin, shows little or no cracking except perhaps in really thick areas, has an overall appearance that is smooth, this indicates acrylics. Fortunately, the difficulty of immediately distinguishing oils from acrylics does not present serious problems once the actual work of restoration has begun.

Public exhibitions can also help your training in identification. Most galleries and museums have examples of paintings in all these mediums and supports; their nature is usually written beside them or is easily available from catalogues. Simply looking at such pictures will give you valuable visual experience. By visiting the same pictures several times you will begin to recognize materials, defects and repairs, and gradually achieve skills that cannot be attained so easily in other ways. If it is permitted (most likely in small, local galleries), take your magnifier and get close to the paintings but *do not touch*. Curators are usually most helpful to genuine enquirers and are immensely knowledgeable.

FINDING THE VALUE OF A PICTURE

The current financial value of a painting is of vital importance to the restorer, because if a painting will sell for hundreds of thousands of pounds, then any amount of time can be spent doing a job that is as risk-free and successful as possible. Restoration is a painstaking and delicate process. Not all the aspects require a high level of skill, but they do tend to be time-consuming; the difficult aspects take even longer. Simply deciding what should be done can take weeks of study, tests and discussion. A painting that will fetch only hundreds of pounds on the other hand may ideally require the same amount of attention, but ways have to be found to cut the time and the cost of the work.

If you are new to picture restoring, financial value is obviously important as, if your car-boot purchase is actually an undiscovered Constable, you will do yourself no favours by tinkering with it.

What is needed is a cast-iron method of being able to tell at a glance how much any picture will fetch on sale. If there is such a method, I do not know of it, and if you happen to discover one please let me know and I guarantee to make your fortune!

In fact, over the many years of my involvement with paintings, the one question I have been asked more than any other is 'why are some pictures so valuable?' We hear of fantastic prices paid at auctions, yet what is not clear is why these same paintings were initially worth a certain amount . . . then their value went up . . . then down, perhaps by several millions. Yet they are the same still pictures with presumably the same artistic value.

The answer is the age-old factor that affects all selling – supply and demand. The auction value of a picture has little to do with its artistic value as shown by its appearance, or the skill of its creator. Artists rise in fashion and 'collectability', and then they fall. A neglected and dismissed painter today may be in the big league in a few years, while a shortage of pictures by one group of artists will result in a rise in prices paid for others.

The effect is easy to see with postage stamps. Some of these, size for size, are probably the most valuable pictures in the world. Why? Because there are people out there with the funds and inclination to collect them, and those which fetch the most are rare and in good condition. Forgeries or copies fetch nothing; they may look the same, but they are not genuine. The difference between this and the art world is that nobody claims that the huge price paid for a rare stamp is anything to do with its aesthetic or artistic value, or the skill of its designer.

There are very few masterpieces and many millionaires, organizations and governments competing for them. They see paintings as items that give them prestige, reflected glory, bigger budgets and more

39

television interviews. Paintings are a tasteful indication that the owner can afford to hang millions on his or her wall. And it is not easy for others to outdo them, because there is only one genuine, original painting. When a millionaire collapses into bankruptcy and the pictures they have so publicly bid for are sold off at a lower price by their creditors, it is not often suggested that they have declined in artistic value.

Although few pictures achieve these financial heights, the general principles of picture valuation remain the same at all levels, although the further down the price scale, the more important the buyer's personal tastes and appreciation become.

Suppose you have a picture, have studied it and think it *may* be valuable. What do you do next?

First, write down a full description of your picture, as follows:

- the exact size of the picture itself, both with and without its frame
- the support and medium of the picture
- the subject and title of the picture, if known
- any signatures, wording or dates on the picture or frame (front and back). If you cannot read them, try to draw what you can see`
- any framer's notes and labels
- any visible damage or old repairs, front and back, and the state of the paint film
- how you came by it, but not the price you paid
- any known history, particularly if it has ever been sold by a well-known auction house, and if so when and what it made.

Then, ask the following people for help:

- the auctioneers who last sold it, if known, via letter or telephone, giving all the above details
- your local auctioneers, on a personal visit by appointment so that an expert is available
- local galleries, on a personal visit to the curator by appointment following a telephone discussion. Curators are not valuers, and though they may give an opinion on whether the painting is genuine, they will not suggest a value. Still, this is a useful step forward, even if, as will probably be the case, they do not allow you to quote their name. Nonetheless, do not necessarily take even the most eminent museum's word that a picture is *not* genuine; only last year I was told by such a museum that a painting was not genuine, and it later sold to an expert at a major international auction house for a large sum
- local experts, recommended by the curator (not a dealer) on a personal visit
- national auctioneers, via a telephone call to their agents in your region (listed in the telephone directory). At the request of the agent, take several careful photographs of the picture, outdoors, not using flash, and send postcard-sized prints of these along with the information detailed above to their head office. They will tell you at once whether the work might be valuable, though you will have to show it to their experts personally before they will set a firm estimate of value at auction. Note that they may make a charge for official written valuations but not usually for informal verbal estimates.

It is not really reasonable to expect antique dealers to value your painting, as they live by their skill in buying low and selling higher. You can ask them what they would give you for it, of course, but this

would naturally be lower than their retail price, frequently half or even less.

FACTORS AFFECTING THE ESTIMATED FINANCIAL VALUE OF A PICTURE

FASHION

A painting's value at a major auction or to a private buyer will be higher if the artist is currently fashionable. Fashion is everywhere in the art world, and painters rise and fall in favour and price as wealthy collectors, corporations and governments take them up or lose interest in them. This factor is much less important when the picture is being bought privately for its personal appeal.

A FAMOUS PAINTER

The more eminent the better . . . but you may never have heard the name! Many artists commanding high prices at auction are barely known outside the narrow art world, which is where the values are established. A private buyer of lower-priced pictures is unlikely to recognize the names of middle-rank painters unless they are local. If the artist is listed in some of the semi-official reference books this will help.

RARITY

It may be the only remaining picture by an artist that is not in some national or private collection, or it may be identifiable as being from a period in the artist's life that is little known. If it is a print, it may be one of which few examples have survived. Only the private specialist collector is likely to

be concerned with this, but if you find such a buyer, the price you can get will certainly be increased.

A FULL, DOCUMENTED HISTORY

A picture may have had an interesting series of owners or other history, which has hopefully been well documented. Such a record is called its 'Provenance' and is a powerful protection against forgeries, very important at the highest levels. A private buyer will also rate this highly; it gives a deeper interest to the picture and makes it likely that the value will continue to rise.

AN INTERESTING SUBJECT

Known personalities in portrait, or self-portraits if the painter is well-known; familiar cities or countryside views; famous buildings or equipment; engines and bridges are some of the most sought after. Note that portraits of unknown people by a minor artist are little valued even if the painting is genuinely old. For private buyers subject appeal is paramount. Personal attraction is the drive that will close any sale and it is here that the unknown 'character' portrait finds its market. Some people buy these and casually put them forward to friends and visitors as a distant ancestor, and since nobody knows who they are, they may just be correct!

AGE

Broadly speaking, the older a picture the better, but age alone does not mean a picture will automatically reach the highest price levels. I have had a genuine 300-year-old print that would not have been worth the carriage costs to sell at a major auction. For private buyers, however, age is

important, and is certainly a great talking-point!

A WELL-ESTABLISHED MEDIUM

In general, oils are valued higher than water-colours or acrylics, originals higher than prints. This factor also appeals to private buyers.

CONDITION

Tears or deep creases in the support canvas or board, flaking, cracked or discoloured paintwork, and embedded stains all reduce the value of a picture. Damaged, dirty and neglected frames may also indicate that in the past the picture has been little valued. Private buyers differ on this; some prefer an unrestored picture because they are hopeful of a bargain, while others (justifiably) fear restoration costs and prefer a picture they can hang at once.

HOW IS THE VALUE OF A PAINTING AFFECTED IF IT NEEDS CLEANING OR REPAIRING?

There is no simple answer to this question; in fact it is a matter that causes heated arguments among artists, gallery owners, auction houses, valuers, restorers and insurance loss adjusters. The disputes are usually about work needed or done on paintings of great importance and of known high value, masterpieces and so on. Whenever one of these is discovered after many years in a disused shed or the basement of a museum, it tends to be put into the hands of a restorer at once, usually at a

major gallery with conservation specialists who then examine it using every means known to man.

The first thing that must be done is to make the picture safe, that is, to stop it getting worse. Nobody denies that this is vital. It is after this that arguments begin to rage about the degree to which the picture should be restored. As discussed earlier, some say that an aged condition and appearance is part of the artistic and aesthetic value of a picture, like the soft patina of centuries on old wooden furniture. Others insist that the object of restoration should be for the picture to match the artist's original as closely as possible, with any defects repaired invisibly. Since it is not always certain what the artist did intend or what the picture first looked like, these are disputes that have no end!

However, in the less highly charged atmosphere of dealing with pictures of a much lower value, here are some guidelines for beginners.

- If the painting is valued by a major auction house (which will of course allow for the defects) you are unlikely to increase its value at auction by amateur restoration; in fact you may well reduce the value a great deal. The reason for this is that buyers at auction usually prefer a picture that is in its 'natural' state for its age as they see the chance of a bargain. Heavy-handed amateur restoration is often obvious and may put many buyers off. There is also the possibility that the proof of its attribution to a particular artist may have been tampered with or reduced in certainty (many a cleaned picture has been judiciously upgraded from an unknown to a known signature). Collectors often go to auctions in the hope of making their own discovery by buying an unrestored pic-

ture; the possibility is gone if all is exposed.

- Professional restoration of a painting is another matter, since then the work will withstand closer scrutiny and the reputation of the restorer may actually increase its value. However, I always advise individuals *not* to restore a good old painting that they intend to sell, but to auction it as it is. It is uncertain as to whether the restoration cost would be covered by any increase in sale price.

- Selling a painting privately is different from putting it into an auction. In this situation, it is the immediate impact of the picture that counts. Few people buying a picture to hang in their home will want to be faced with restoration costs immediately. In this sort of sale a paint-

ing that started out scruffy, torn and covered in dingy varnish will make a great deal more if it has been neatly repaired, pleasingly coloured and re-varnished. All this work may be possible even if you have not tackled picture repair before. The best method of learning and testing restoration skills is to try them out, as discussed in Chapter 5, but it is advisable to do some buying yourself first at general auctions. There may be no great masters, but for a few pounds you will be able to pick up dozens of battered, discoloured, tatty old prints, sketches and amateur oils, perhaps even some nice, appealing pictures looking for loving care; these are your test and trial pieces on which you will gain vital experience.

— 5 —

TAKING YOUR FIRST STEP

A SIMPLE PRINT CLEANING

Outlined below is a step-by-step pictorial demonstration of how you can restore a foxed print, that is one which has been damaged by a common fungus and chemical effect. The materials necessary are extremely basic and easy to obtain, and suitable prints on which to work can easily be found at local auction houses or junk dealers. By performing this hands-on trial you will begin to establish the practical skill that all restorers must have.

Obviously, you need something to restore. Do not start with an original painting. For your first attempt find a smallish print with no colour (black lines only), up to a foot long, and eight or nine inches wide.

Visit your local junk or antique dealer and take your magnifier with you to look

Fig 58 This simple foxed print of castle cost very little as a practice piece.

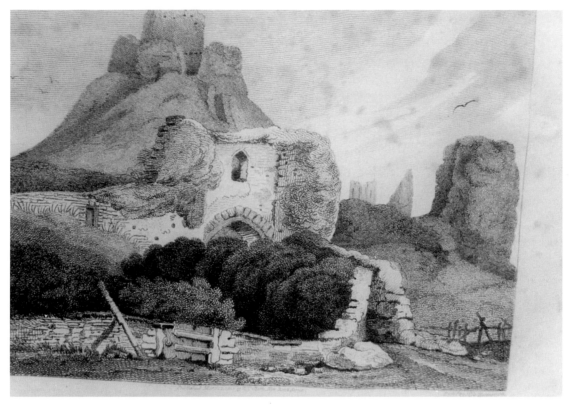

Fig 59 In close up, various folds and marks may be visible.

Fig 60 The rear shows clearly the effect of 'foxing'. Take a photograph!

for a picture with fine detail.

Nearly all such prints, if they are over fifty years old, will be damaged in some way. Choose one that has the brownish spots of foxing. Do not worry about whether you like the picture yourself; it might be better if you do not, then if all goes wrong you will not be upset! Go through the inspection stages described above and make notes. Take photographs of the picture, out of doors in good light, and carefully focused. It is good to develop precise habits early on, even though you may know that the print is essentially worthless. It is all practice in recognition and system, and is your most valuable asset – experience.

THE TOOLS YOU WILL NEED

- A soft pencil.
- A domestic palette knife.
- A modeller's scalpel tool.
- Two shallow plastic trays or dishes large enough to accept the print with at least 50mm (2in) space all round. You can find these in garden centres for use in greenhouses, or, alternatively, higher quality and more expensive ones at photographic suppliers. A reasonable starting size is 500mm x 400mm (20in x 16in). Different coloured trays are useful as it is best to keep each for its own purpose.
- One piece of 6mm (¼in) float glass (plate glass) cut to fit in the dish with a 25mm (1in) space all round. Buy this from any glazier and ask for the 'arrises' (the sharp edges of the cut glass) to be taken off and the corners rounded. This makes the glass safe to handle, with reasonable care of course. If you are worried about using glass, get a piece of flat, transparent plastic, 6mm (¼in) or more thick, and of the same size, from a DIY supplier and shape it with a jigsaw.
- A pair of thin, cotton gloves to prevent the paper coming into direct contact with your hands.
- A large jug for mixing and ladling out the liquids.
- A clock or watch (not on your wrist but placed where you can see it easily), with a second hand.
- A pair of waterproof surgical gloves.

YOUR WORKPLACE

As you will need clean water and a place to drain things out, a work place situated near a sink is best. There is no hazard to health or risk of staining your sink because

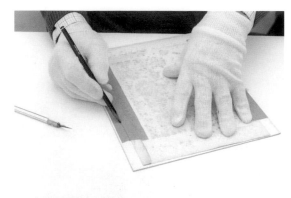

Fig 61 Pencil mark the outline of the print under the edge tape.

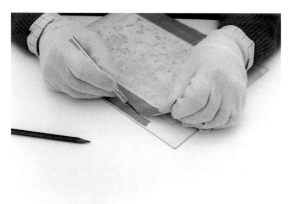

Fig 62 Slit the tape free from the mount.

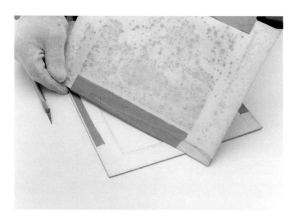

Fig 63 Remove mount but do not re-use it.

Fig 64 Peel the tape free but do not force it.

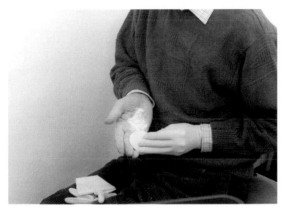

Fig 65 Talcum on hands will ease putting on waterproof gloves.

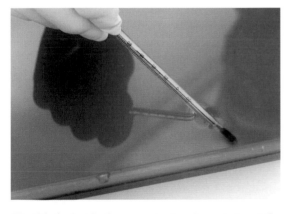

Fig 66 A simple thermometer is adequate to get the temperature right. Photographic stores stock them.

you will only be using very mild bleach.

You will need:

(1) A chemical bleach called 2% sodium hypochlorite. This is the cleaning material, and is very simple to obtain. Buy a litre of the bleach sold under various trade names for sterilizing babies' nappies ('2% sodium hypochlorite' may appear on the bottle). The make is unimportant, since all are much the same.
(2) Water. You need enough available to re-fill the dish six or seven times. At the tray size recommended above you would need about 20 litres (4 or 5 gallons).

DEMONSTRATION 1 – IMMERSION CLEANING OF A LOW-VALUE PRINT

The basic idea is simple. You are going to immerse the print in bleach to get rid of the foxing spots, then rinse and dry it.

Put on your cotton gloves. If the print is in a mount support, mark the edge of the securing tape with pencil.

Use your scalpel to slice the tape through, just outside the print itself.

Lift the print clear. Slitting the tape reduces the risk of tearing the print edge.

Often the securing tape will pull free readily, but get into the habit of working gently with paper. It is better to leave it in place than pull hard and tear the print.

Now change into a pair of waterproof surgical gloves. Though the paper bleach is not harmful, it is always sound practice to use such protection. In later years you may be using much stronger materials and the habit will then be well ingrained. Sprinkle talcum powder on to your hands and into the gloves for ease of fitting.

Half fill one dish with plain warm water. As with all restoration, working at the correct temperature is important. Chemical

47

action speeds up rapidly as the temperature rises, and 16–20°C (60–70°F) is therefore a useful average liquid temperature to aim at. Add three drops (no more) of washing-up liquid and swirl it round. This is your wash dish. Mark the dish in some way so that in future it is kept solely for this purpose.

Note that some cold water supplies are *very* cold and chemical processes are slowed down in such temperatures. If yours is like this, draw the right amount off and allow it to warm up before starting work.

Then mix enough bleach to fill your second dish roughly half an inch deep, using one part bleach to two parts water, and at the same temperature as before. Add one drop of detergent. This does not wash the print, but reduces the surface tension and helps the water flow smoothly. Again, mark this dish clearly.

Rest the print on your glass and allow its lower edge to overhang the wash dish by an inch or so, holding it in place with your fingertips. Then, very slowly glide the glass and print together into the wash water, starting at one end of the dish. The paper will nearly always darken and change colour the moment it is wetted (sometimes to a frightening degree!), but this is normal.

If the print tends to float upwards rather than sink, draw it back a little and wait for it to absorb more water. Do not be tempted to push the paper under with your fingers. The paper will now be very fragile indeed, so do be patient. It may take time to sink, but it will do so in the end. Then let the glass and print glide together to the bottom of the dish. Rock the dish gently to make the water move to and fro over the print. Leave it in the water for two or three minutes, although timing is not critical. The object is to rinse off surface dust and fill the paper texture with water.

The next step shows the purpose of the glass. Grip the ends of the glass firmly and lift it *slowly* from the water, tilting it at an angle so that the water runs back into the dish, but not so steeply that the print slides off. At first you can keep your fingertips over the edges of the print to stop it sliding, but it will then cling tightly to the glass as it leaves the water, and will not tear, as it probably would if you picked it out with your fingers alone.

If there is any adhering tape, lifting the print edges with your palette knife rather than your fingers will reduce the risk of tearing as you draw the tape off (manipulating wet paper is a basic and essential skill to develop).

Drain the water off and then look at the clock. Wait for exactly one minute and then glide the print and glass together into one end of the bleach dish, sliding them under the surface until they are completely immersed. Now watch the paper surface for signs of lightening. It is very unlikely that there will be a dramatic change with this strength of bleach (if it *does* lighten quickly, remove the print at once, slide it back into the water dish and check the elapsed time in seconds). If no dramatic change takes place, withdraw the print after exactly one minute and return it immediately to the wash dish. Rinse it by rocking the dish for about another minute. The object is simply to stop the process of bleaching.

Withdraw the print and glass as before, making sure that they are clinging tightly together. Tilt them so that the water/bleach drains away. Then study the print surface. What you are looking for is to see whether the paper is any lighter than it was when first wetted. Are the foxing spots still present and still brown? The chances are that there will be little change. Even so, study the appearance carefully. This is valuable experience and will help you later.

Another advantage of the print clinging to the glass is being able to look through the wet

Fig 67 When the dry print enters the dish the paper will discolour.

print at a bright light (do not hold it directly above your eyes or the bleach solution might drip into them). You may be surprised at the details of dirt and discolouration you can see, in fact, some of the foxing spots may actually appear darker than when you started. Others may now show a glimmer of light through them, like bright little holes.

Repeat the bleaching process for a further one minute. Rinse and check again.

Ideally, the print should be completely dried following a five-minute wash in several changes of water. The drying can take place on the glass itself, to which the print will then possibly stick. Do not attempt to prise it loose; you can see the results well enough and it will free itself on its next immersion. The paper will probably be whiter than at the start and the foxing a little paler, some of the smaller spots having

Fig 68 Use fingertips only to hold the paper in place until it is soaked.

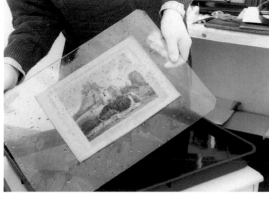

Fig 69 When it is lifted from the water, the print will remain in place without touching it.

49

Fig 70 Remove the remaining wet tape with a blunt-sided palette knife, lifting it gently free.

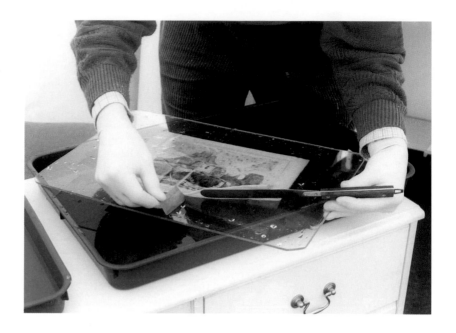

vanished completely. Others may well still be present, but look less dramatic.

Return the print to the bleach solution, noting the time. Watch it carefully, in particular the foxing spots. When you look down at these they may still appear dark, though fading. In fact they are gradually becoming translucent, and what you see through them is the shadowed base of your dish. When you look upwards through them towards the light, many will be completely transparent. This does not mean that you now have holes in the print; it is simply the effect of the bleached fibres in the spots allowing light to pass through, as thin, wet, white paper often does. Once again, glide the print into the wash dish and rinse it thoroughly.

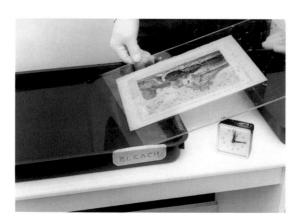

Fig 71 Glide the print into bleach for a measured time . . .

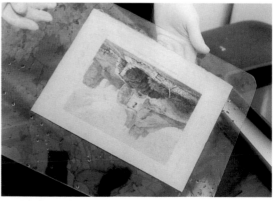

Fig 72 . . . and remove it at intervals to check progress of the bleaching

Fig 73 By looking up through the print at daylight, the foxing can be studied as it fades. Bright spots indicate bleached foxing letting through more light.

Fig 74 Fold the washed print in clean white blotting paper overnight.

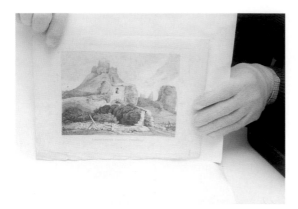

Fig 75 The castle print may call for several bleachings before it is free of foxing.

Fig 76 You can straighten curled dry paper by drawing it smoothly over a sharp edged table.

Finally, dab off surplus water and leave the print folded in clean blotting paper overnight.

Next day, check if the print is markedly lighter and the foxing reduced or eliminated. The transparent areas will almost certainly now be pure, opaque white. If not, repeat the bleaching process. You will see that many of the foxing spots seem to re-appear when wet. They will vanish again once the print is dry.

Incidentally, if a paper print or drawing curls up you can easily straighten it out by drawing it gently over the edge of a table.

Use your camera to record the result of your first work. In years to come I hope it will remind you how much you have progressed.

— 6 —

VITAL TERMINOLOGY II

To fully understand how artists paint and restorers rescue pictures you have to be familiar with five further specific terms: supports, grounds, varnishes, solvents and inks.

SUPPORTS

Supports are simply the materials on which pictures are painted, drawn or printed. The usual supports are paper; canvas, preferably linen or cotton, stretched on expandable wooden frames; various kinds of board; and sometimes even ivory, glass or metals such as iron, copper or brass, especially in the Far East. In recent years plastic or aluminium have been used. The support must be strong enough to withstand handling, rigid enough not to distort when framed, as

Fig 77 Support canvases come in various colours and weaves

light as possible, should take paint properly and be suitably priced (none are perfect!).

Canvas is first stretched over and tacked to rectangles of wooden frame pieces called stretchers, which have adjustable corners and are capable of being driven apart by wedges. These tension the cloth evenly. The canvas will probably still appear somewhat textured, and this is often called its 'tooth'. This effect might still show, even through several quite thick layers of paint.

GROUNDS

Most supports need some form of treatment to prepare them to accept paint or ink before the picture or print is made.

Paper should be treated with 'size'; most artists' papers are bought already sized, often with gelatine which reduces the porous nature of the paper so that the colours do not spread (blotting paper is unsized). No other coating is necessary except when using unusual methods, such as oil paintings on paper, when some sort of coating may be applied to stop the linseed oil being absorbed too greatly. Paper for printmaking is often specially coated and otherwise treated. In advanced work it may be necessary to replace any of these lost during immersion but this is not essential. The study of paper is something that you will have to pursue as you progress.

Canvas was traditionally treated first

with rabbit-skin glue size to protect it from attack by the linseed oil in paint. Then a priming material such as Gesso, acrylic-based primer, white lead or a combination of these, was applied as a foundation for the actual painting to follow. Many coats of this may have been applied to fill the pores of the canvas and give it a smoother surface. Gesso is a rather vague name given to several types of paint used in the past. They were frequently oil-based (or sometimes water soluble) and were suitably porous to accept oil paint on top.

Modern 'acrylic Gesso' is not a true Gesso but simply an acrylic-based white paint. This does not attack cloth so does not need a size underneath it. Many modern, ready-prepared artists' canvases are supplied covered with such acrylic Gesso. Note that, oddly enough, due to the way paints bond, acrylic-based Gesso will accept oils on top, but oil-based Gesso will not safely and permanently accept acrylic paints.

White lead is a traditional heavy paste thinned with turpentine.

Wooden or cardboard supports need no size, but will normally be first primed with several coats of Gesso, other flat oil paint or acrylic primer, to provide a secure foundation for the paint and conceal, if desired, the texture of the board surface.

After the size and primer, traditional oil painters often applied another even layer of white or coloured paint, sometimes called the working ground, to add lightness or a particular colour tendency to the picture they later painted on top. Many painters had a particular favourite choice of such working grounds and these are one means of identifying their work.

Glue size and some old Gesso grounds dissolve in water and this creates a great hazard when cleaning. Pictures in oils should *never* be washed in water as the size or ground may fail and the actual paint will fall off . . . not a pretty sight for a restorer's client.

VARNISHES

These are natural or artificial resins and waxes dissolved in turpentine, alcohol or other solvents to make a clear or faintly coloured liquid that sets into a tough, glossy, protective skin over the completed picture. The gloss also intensifies contrasts and colours to give a sharper and more brilliant image. The use of varnishes is very important to the restorer, and picture owners are often amazed at the difference they make.

Note that practically all varnishes are glossy. Those that are matt are simply gloss varnish with powder or waxes mixed in, making the dry surface lumpy or irregular and breaking up the reflections. These protect the surface in the same way as gloss varnishes but the increased brilliance of the picture will be lost.

SOLVENTS

Mediums, varnishes and inks all change from a liquid to a solid once they are applied and have dried out. A solvent is a material which changes a solid back to its original liquid; some solvents go even further and change solids into vapour or gas. For example, many modern picture varnishes can be liquefied and wiped away using turpentine and white spirit. One of the problems, however, is that the solvent used to remove the old varnish may also liquefy the paint beneath. Solvents, some of which are very powerful, are used extensively in restoration. In fact, probably the greatest skill of the restorer lies in the choosing and handling of solvents.

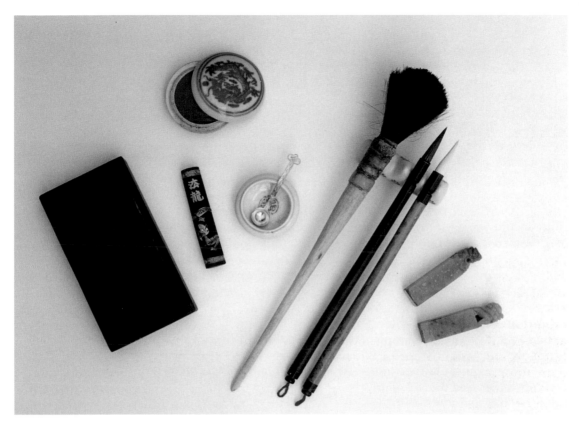

Fig 78 Chinese painting gear includes bamboo or hand knotted bristle brushes, a black trough for ink mixing, decorated ink sticks, ground pigments, mixing dish and seal markers.

INKS

Chinese and Indian inks are solid tablets or rods of carbon and glue, often gilded in exotic patterns, and ground with water into ink in the black trough immediately before use. The material is very easy to bleach, but its security of attachment will vary with the skill of the artist.

Western bottled inks are thin liquids, ready diluted for working with pens or soft brushes. Some are made using pigments, while others use liquid dyes, and some change chemically as they are applied.

Their glue is called a 'vehicle', but this is really only another word for medium. The production of inks can be surprisingly complex and there is a whole industry devoted to making special inks for printing. In restoration work the most important issue is how permanent they are, and this can vary a lot. Black is usually almost completely permanent, but colours may fade or be changed in the cleaning process, especially those not intended for art printing. In general, treat coloured inks as water-colours, black inks as prints.

OIL PAINTINGS

All methods of oil painting begin with the application of the size and ground. The initial preparation of the working canvas and ground used to be long and laborious; all the paint and Gesso had to be hand-mixed and ground, and many famous artists started their careers as apprentices mixing paint for their master employers. These days, most artists use canvases which have had the size and Gesso applied in advance at a factory. Indeed, most canvases sold in art shops dispense with the size altogether and have a simple coating of white acrylic, which is not too heavy, with the canvas weave still visible. Working ground must still be applied to fill the weave if the artist needs a smooth, even surface, perhaps for very detailed pictures.

With their preparation complete, some oil painters made a careful, full-sized charcoal drawing directly on the working ground, while others made the drawing on a sheet of strong paper. This was pierced along the lines and charcoal dusted through as it was laid over the ground, as a guide to their work. Its guidance was of course swiftly lost as the paint was applied, but the template could be re-used over each layer of paint as soon as it was reasonably dry. Traces of charcoal are sometimes found during restoration. The charcoal lines were sometimes strengthened by very thin paint applied with a fine brush, and these also are sometimes found during cleaning.

Following the working ground and the underdrawing, the next layer was usually the oil paint, applied in complete coatings, lines or patches. However, some painters actually did an undetailed, broadly drawn underpainting first, showing the general effects of the colours before adding finer details on top.

The choice of colours was known as the 'painting's palette'. Since painters tended to favour a limited number of pigments, these became known as the 'artist's palette', and were very personal and characteristic. Artists generally used only a limited number of pigments, about twelve perhaps, and many pictures would not include more than six or seven of these. As pigments were hand-ground, old paint tends to be less regular and consistent in texture than modern, machine-ground pigments. This is one of the many signs of age that enable experts to identify genuine paintings.

Also, the way each stroke was applied, and the choice of brushes, gave each artist's work a characteristic appearance, rather like handwriting, and is another means by which experts can identify the work of a particular artist.

A careful restorer will study the brush work of any painting they are working on, either to ensure the same strokes are used to make a perfect match, or to deliberately use quite different strokes so that the restored section can be identified. In this case, note the thin paint, with the canvas clearly showing, and the swirling, confident curves and dabs. While oil paint was still wet, it might be worked over by

Fig 79 Restoring a painting must take into account the many ways that paint can be applied as with this thin, vigorous brushwork in oils.

Fig 80 This painting's golden glow might occur by varnish and pigment discolouration. . .

Fig 81 . . but the canvas edge with yellow glaze visible confirms that it was created by the artist deliberately.

stroking and dabbing, using special brushes without any paint on them, often made from the tails of badgers (modern 'blenders' are still marketed coloured to resemble badger hair). Very finely graded colour changes, as in a sky for example, were produced by blending specks of different pigments in this way.

To further modify the effects and the colours of the paint layer, many artists added final glazes that were actually coloured, translucent varnishes, as in the golden haze in this picture.

Their effects were very delicate and the coatings extremely thin, but may be visible at the canvas edges. Artists might use dabbers, wads of fine cloth impregnated with the glaze, instead of brushes to apply them. Often, several such glazes were applied one over the other, and in different areas. Complex interactions in the layers could be used to give shimmering and translucent effects.

Very sparse dabbings, brushings and rubbings of undiluted tube paint were also be applied over dry paint layers, giving a textured effect called 'scumbling'. Where a heavy impasto coat was needed, paint might be transferred from knives and thick layers sculptured during the drying period.

The underlying oil paints were allowed to mature and dry for several months, and the completed work exposed to direct sunlight. This was said to have a strengthening effect on the paint, a belief that appears to have some foundation in fact. Certainly, if newly completed paintings are stored in dark places, they benefit from later being exposed to strong daylight, not full sun, for several days. Finally, varnish – a clear resin dissolved in a diluent such as turpentine – was applied over the picture. Its purpose was to provide the oil paint with a protective surface that would resist wear and atmospheric

attack, and to intensify the colours and contrast in the painting by reducing the diffusion of light falling on its surface. Occasionally the varnish would be slightly coloured, making it technically a glaze.

To restorers, the surface scumbles, glazes and varnishes are most important as they can easily be removed accidentally by heavy-handed cleaning. It is the gradual but inevitable darkening and dulling of the varnish, however, that usually has to be corrected in the restoration process. In some periods, varnishing and finishing were carried to such lengths that a virtually mirror polish was achieved, known as an 'academy finish', and galleries would have 'varnishing days' before opening to allow the artists to add one, final lustrous shine! Generally though, whether applied by brushes or knives, the paint surface was left with a number of irregularities, rough and smooth patches, even definite humps and ridges. This surface texture is known as the 'impasto'; the works of Van Gogh display heavy impasto. This too can create problems for the restorer, as such thick layers tend to shrink and crack on drying out, and may break up and fall off in flakes. Paintings such as this have usually had these defects repaired.

Though traditional methods are still used by some artists, the application of glue size has been practically eliminated by the use of white acrylic primer direct to the supports. Acrylic may also be used for the texture-filling ground and even the underpainting. Acrylic dries in hours and greatly speeds up the progress of the artist.

It is now very unusual for any paint to be made by the artist personally. From the nineteenth century onwards, colours were increasingly sold ready-mixed with medium in collapsible tubes. If tube paint feels too thick to brush out satisfactorily it can be thinned with a diluent, almost always

Fig 82 Tube paint for restoration is often too wet. Spread it on newspaper to absorb the surplus medium and diluent.

turpentine or white spirit, and applied with brushes or painting knives, but rarely as a spray. Note that some artists add medium such as linseed oil instead of diluents to thin out their paints. This will often produce a poorer film, which may sag into wrinkles or bulges. The medium also lowers the density of pigments, weakening the colour intensity, and is more likely to yellow with age. In fact, modern tube oil paints have, if anything, rather too much medium and thinner added to lengthen their shelf life. Restoration work is often better done with paints that are a little less soft.

Restorers generally prefer a less runny, more concentrated paint for re-touching work. It is therefore common practice to spread fresh tube paint on absorbent paper to extract some of this surplus before use. If this is taken too far on new

works, however, the result can be a paint with too little medium that will not achieve full strength – there are no easy answers in painting!

Several layers of paint may be applied, as in traditional methods, but many modern paintings, especially those by amateurs, often have only one coat applied direct on to the ground. This method became widespread among the Impressionists and was known as 'alla prima'. If even moderately thick applications are made like this, they may take a long time to dry and frequently shrink and crack. Glazes and scumbling may still be applied over part or all of the picture to change the colours and textures, but the technique is less elaborate.

Finally, after allowing three months or more for drying, a coat of varnish should be applied to give protection and bring out the colours. The current fashion is for less glossy finishes, however matt varnishes that protect but do not bring out the colours to the same extent as gloss varnishes may considerably reduce the brilliance of the painting after cleaning.

New paintings are now often sold as soon as they are touch-dry, without any varnishing at all. This is sometimes due to ignorance about the technical need for varnishing, or simply to avoid the three-month delay in selling. The result is usually a premature dulling of the surface and loss of colour intensity, perhaps followed by cracking, frequently within months but often occurring so gradually that the owners are unaware of the changes until they are far advanced. Restorers receive a lot of work as a result of this technical error.

HOW OIL PAINTINGS DETERIORATE WITH TIME

ACCUMULATING GRIME AND GREASE ON THE PAINT SURFACE

This is simply dirt caused by the environment. In the days of coal fires, candles and oil lamps, smoke, fumes, soot and dust were everywhere. Tobacco is another staining hazard, while the greasy deposits from cooking accumulate for years. *Some* cleaning was carried out; it is said that in many great houses the family pictures were occasionally taken out to the lawns and briskly washed with yellow soap – not a procedure I would recommend!

Encrusted dirt can eventually attack the varnish and paint and is usually the first thing to be removed. However, I have occasionally come across very dark, dirty examples where the thick, greasy coating appears to have actually protected the paint surface.

DARKENING OF THE SURFACE VARNISH

All varnishes (and there have been centuries of experiment and research into this matter), will change colour and darken with age, eventually turning brown or even black, though clearer varnish may still be visible around the edges of the painting where it has been protected by the frame rebate.

Many resins have been used, with varying success. The traditional Damar varnish (Damar resin beads dissolved in natural turpentine) is probably still the best all-round choice for present use. Though faintly yellow, as seen in bulk in the jar, it is effectively transparent when freshly

applied. Nonetheless, it does gradually change to a deeper yellow, and later to brown. Some modern synthetic varnishes are more resistant to discolouration, it seems, but it will take a century or two to be certain. For the restorer, varnish is enormously important. Indeed, cleaning an oil painting in most cascs means simply removing its old, discoloured varnish and applying new.

DARKENING OF THE SURFACE GLAZES

Underneath the varnish are the glazes, if any. These, being effectively coloured varnishes, also darken and their colour may be completely obscured. Indeed, the uppermost glazes and the surface varnish will often be closely intermingled, and this is one of the most intractable problems in restoration. The glaze was certainly part of the artist's original work, and should never be removed, yet removing the surface varnish, not usually applied by the artist, will probably remove the glaze as well.

COLOUR CHANGES IN THE MAIN PAINT FILM

Yellowing of the actual paint layers is caused by the deepening colour of the linseed or poppy oil medium, though strangely enough, very old paintings seem to be less affected than more recent works. This problem cannot be directly corrected because the medium is the fundamental 'glue' that holds the pigment in place.

Other colour changes take place because many pigments, especially older ones, are inherently unstable, gradually fading or altering in hue over the years. In general, older traditionally painted pictures will be in the most permanent materials then available. These were often the 'earth' colours – the browns, raw

umber and burnt umber, the reddish raw sienna, burnt sienna and yellow ochre, which hardly change at all. Some permanent pigments were very expensive, such as ultramarine blue, which was made by grinding up the semi-precious stone Lapiz Lazuli, or fine red vermilion, which was transported at vast expense from the Far East. Where sound pigments were not available the artists might have avoided the problem simply by not painting pictures that called for such colours. The painter Franz Hals often used only black, white, a yellow and a sienna, yet produced masterpieces that have survived well. Much successful research has been directed at finding new pigments that will retain their original colours better, and the introduction of new pigments at known dates helps to establish the age of a painting in which they are found.

GRADUAL INCREASE IN THE TRANSPARENCY OF OIL PAINT

All oil paint is very slightly transparent, though this is not normally apparent when it is first applied. Over many years the effect, known as 'pentimento', gradually increases and it is common for the lower paint layers and guidance markings to become visible as shadowy forms slowly developing in the background. There is no cure for this (except drastic overpainting), and correction is not usually attempted. In any case, if the picture is old enough to have such an effect you would be well advised not to work on it.

CRACKING AND FLAKING OF THE PAINT LAYERS

Cracking of the dried oil paint is another form of deterioration that is of fundamental importance to a restorer. It can take several

Fig 83 Oil paint cracking takes many forms, but if there are no loose particles some work can be done.

Fig 84 This portrait has serious problems with surface flaking and is shedding particles dangerously.

forms, and becomes worse as the picture ages. Very thick paint layers, such as heavy impasto applied with knives, are particularly vulnerable. The outer surface dries first and leaves the inner layers cut off from the air. The lack of oxygen slows down the curing process that sets the medium, and the interior of some lumps, if examined even after a year or more, may still be soft. This irregular drying causes stresses to develop, shrinking and deforming the paint and splitting its surface. In any thickness of paint, the cracks may spread right down through the pigment layer, the underpainting and the ground in time. I have often seen cracks right through the paint that were clearly visible from the rear of the canvas. The process described also loosens the grip of the paint on the canvas itself and it may flake off in large chunks – some clients have brought in pieces they have collected off the floor. (This is a good idea, incidentally, as it may be possible, though expensive, to re-attach them.)

Cracking of thinner layers is just as prevalent, though some of the flakes may be much smaller, even a coarse powder size. This can go unobserved for a long time, the only indication being tiny white flecks appearing in the body of the paint as it slowly sheds its surface in fine dust particles and chips. The hold of the paint may become so slight that simply taking the picture down from the wall precipitates a positive avalanche. This is a serious condition and often effectively destroys the work. Repair is time-consuming and should not be attempted by the inexperienced. Indeed, it is guaranteed to make the professional restorer wish for some less stressful occupation!

CRAQUELURE

There is one form of cracking that is almost universal in old oils. Look closely through a magnifying glass at an old oil painting in a gallery, or even a first class full-size colour print of a painting. Over virtually the whole surface you will probably see a fine, interlaced and very complicated web of cracks showing as dark lines. This is craquelure. Note that it is in the paint layer

61

Fig 85 True craquelure is the normal result of hundreds of years of paint shrinkage and should not be concealed.

not in the varnish, though to complicate matters, this too may be cracked in a different pattern. True craquelure is still visible even if all varnish is removed.

This fine cracking is the result of centuries of gradual shrinking and warping of the linseed film, but so slow and even is the process that it often appears as though none of the paint has actually broken free and dropped off. If you do study such a picture for some time in a good light however, you may see that there are certain small areas with no craquelure, although the paint may look the same. These are probably old areas of inpainting, where damage has been re-painted.

More difficult but not impossible to spot are areas in which a repair has not only been newly painted but where imitation craquelure has been cut into the surface. It is rare for such marks to have the accurate, individual pattern of the craquelure. Nowadays it is not ethically acceptable to imitate craquelure in this way, but it is done nonetheless, particularly for private owners and dealers because, like the worn patina on old furniture, it is valued as a true sign of antiquity. Where a totally undetectable repair is required after an inci-

dent causes a loss of paint, artificial 'cracks' may be carved into any restoration to match the overall pattern, however this is frowned on for important work. Forgers have even placed new pictures in ovens to shrink the paint swiftly and so simulate craquelure, but the effect is unrealistic.

FUNGUS ATTACK

This may appear as anything from minor traces of mould on the back of a damp canvas to a full-scale infestation of white, green and black fungus, spreading over both sides of the canvas and lifting the paint film from its support.

DEFECTIVE METHODS AND MATERIALS

In early Victorian times, Vandyke brown, an oil paint derived from earth and bitumen, became popular among artists as a substitute for the well-used burnt umbers. Unfortunately, within twenty years the paintings were suffering disastrous surface damage caused by the dramatic shrinkage of the dried film. Huge dragging splits appeared in the dark paint surface, sometimes exposing the lighter ground and appearing almost like crocodile skin. These still turn up from time to time as family portraits are inherited and inspected for valuation, and it is almost impossible to do anything with the affected areas, usually the dark background and black or brown clothing worn by the sitters, except to fill them in completely and re-paint the trenches. Even then, the shrinkage will continue and further work will become necessary.

Another disaster in the field of painting was the use of a late eighteenth-century medium called Megilp, a mixture of a heavy Mastic varnish and strong linseed oil which formed a smooth gel effect that seemed to offer slicker, swifter brush work.

Unfortunately it also produced a paint film subject to every kind of defect – poor adhesion, swelling, blistering and so on. It is so unsound that you could strip a picture painted with Megilp in double quick time, whether you intended to or not! If a painting from the Victorian period seems very responsive to initial solvent trials, try to find out whether the artist used this medium. If so, leave the picture alone.

The damage done by these 'new' materials was caused by the natural desire of painters to develop their art, but most were highly trained in long-established methods and were soon able to recognize these defects and abandoned the materials. This is not so today. Painting as a craft has been severely affected by the neglect of technical training in art colleges over a number of years. In general, it is far more hazardous to undertake restoration or repair on recent pictures than on the old masters; you simply cannot be certain that technically sound methods have been used.

Many errors are encountered. Overthinning with turpentine to make wash effects produces a thin, weak film; incorrect oil absorption gradation in the paint coatings causes cracking; adding powders, sand and so on to produce textured surfaces generally prevents the proper glueing action of linseed oil. Many of the problems of recent paintings are caused by the rise of so-called mixed media, in which different and often incompatible painting methods and materials are assembled in one picture. Materials that are inherently unsuitable have been crudely used in ways that almost ensure collapse, sooner rather than later. The lack of fundamental knowledge of paint and adhesive technology has resulted in unnecessary problems for restorers as defects rapidly appear. In fact, even new paintings from some popular art figures pass almost at once into the hands of a restorer who must correct technical errors that will destroy the picture if left untreated. A simple modern example is the application of acrylic resin paint over oil-based underpaintings. The adhesion is unsound for original work as thin surface acrylic can be relatively easily removed or will peel off by itself, so much so that I usually use acrylics to re-touch oil paintings, enabling my work to be identified and removed at a later date without harming the underlying original. (Incidentally, the reverse is not true; oils adhere well to acrylic underpainting.)

I have also seen large paintings in acrylic completed on boards secured to a framework by plain steel nails; within months every nail was visible as a dark spot of corrosion right through to the surface. That acrylic paint corrodes steel should be an integral part of any competent artist's knowledge if he or she works in that medium. In studying any picture painted since 1950 a restorer should look out for technically surprising work creating almost unrestorable results.

PHYSICAL DAMAGE

I have had pictures brought in for restoration which have been gashed and torn, burned, scarred by acids, drenched in various undesirable liquids, eaten by termites or chewed up by dogs. Famous paintings have been flooded, crushed in earthquakes, even shot through by guns. Many have been restored in spite of their injuries. Let us look at these problems one by one.

Gashes and Holes
Gashes and holes in a picture are common; most occur during transport,

especially when moving house. It seems that chairs have an affinity for paintings, their legs often finding their way through even the most careful packing arrangements. Such holes are essentially punctures, with the surrounding material intact. Repairs to canvas are relatively easy, using patches, but do take a long time and are hard to make invisible. Board repairs will depend on the precise material used but are also fairly simple.

Slashes and gashes are linear in form, usually following the weave of the cloth and sometimes reaching out to the canvas edge, even cutting the picture in half. A picture in this state may need backing with a completely fresh canvas, a process commonly, though incorrectly, called 're-lining'. This is also often required when very old pictures have developed a number of cuts in various places, perhaps with loss of paint from wear. The nails holding such a canvas to its stretcher frame commonly cause tears, and the canvas edge may then become so weak as to make it impossible to re-fasten in place. A new canvas and stretchers or a solid backing board is then the only practical solution.

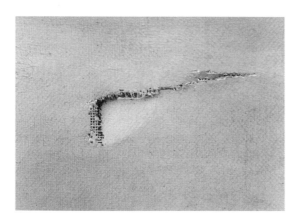

Fig 86 Torn canvas is a common problem, not too difficult to repair.

Paintings on wooden panels may be partly or completely split, gouged by some accident or chewed into holes by pests such as woodworm, termites or rodents. If the damage is old, the individual broken pieces may have warped very badly. The restorer's time might be better spent putting the wood to rights, rather than restoring the paintwork.

Burning or Scorching
Heat can totally destroy the paint and its support, char it unrecognizably, cause it to be drastically altered in colour and made very brittle, or distort its surface while retaining its colours. It is a matter of degree. Even if part of a painting is completely destroyed, it is sometimes possible to produce a workmanlike reconstruction, particularly if any photograph – even a black and white one – can be found of the original. It needs the skill of an artist, and precision work in re-touching and colour matching. Moreover, heat usually produces profound weakening of the paint, and the picture may never be wholly sound again.

Liquid Damage
Spillages on to pictures occur once again mainly in house moves. Floods have occasioned havoc to great collections, as in Florence, and many private houses are flooded each year. Wooden panel paintings wetted *briefly* need suffer little damage provided they are dried out slowly, without heat and while clamped flat. Canvases are another matter, however. Old ones with water-soluble Gesso grounds may disintegrate completely. As with boards, the key is keeping them flat and drying them slowly, without heat or movement.

HOW OIL PAINTINGS ARE RESTORED

Before even planning restoration work on oils, take a photograph of the untreated picture, in sunlight and at as close a range as possible, using a tripod or other camera rest. If possible, have the results enlarged. It will provide both a record of your work and progress, and a guide if any re-touching is later called for. It may also enable you to replace some part of the image that is accidentally damaged or obscured, and also serves to remind you, and its owner, of the state from which you rescued the picture. It is an excellent habit to develop as a restorer.

Study the painting carefully. If there are extensive cracks, and under high magnification the surface reveals small 'islands' of paint starting to curl upwards from the canvas, or indeed to fall off, the repair process will be long and difficult. This is one of the most difficult restoration procedures and can go wrong even in the hands of an expert. If you are new to the business, do not attempt it unless you are prepared to risk causing damage for the sake of learning and experience. Instead, store the picture, laid flat and free from disturbance, in a dry place, and come back to it later.

If the surface is *not* flaking too much, but feels and looks sound, you may be able to go ahead. Make a detailed written survey, looking for and listing the sorts of defects described. Some of these will be interrelated: cracking with flaking, surface dirt with darkening varnish.

A single set of procedures cannot be laid down for every individual restoration case, however a typical sequence for working on a non-flaking oil painting will be as follows.

If the work is on a board, no real preparation is needed except to take the painting out of its frame and lay it on a flat, firm surface under a good light. Bright daylight, not full sun, is ideal.

A stretched canvas needs preliminary work, however. You will tend to press downwards on the canvas while working on it and it is vital that it should not be bent sharply, especially over the inner edges of the wooden stretchers, as this will produce or increase any existing cracking. (Cracks following the line of the stretchers may well be already visible if the painting has been allowed to sag for some years.) Tuck strips of tough card under all the stretchers to support the canvas.

Fill the rear space between the stretchers with suitably thick blocks of heavy plywood up to just beneath the canvas.

Secure the filling with heavy adhesive carpet tape.

DEMONSTRATION 2 – SURFACE DIRT REMOVAL AND RE-VARNISHING OF AN OIL ON CANVAS

With the canvas safely supported at its rear and out of its frame we can see that the edges of the painting are a different colour from the overall surface. They have been protected from discolouration by the frame rebate. What you see is the original colour used by the artist; the rest is dirt or varnish discolouration, usually both. Start by removing the surface dirt, often accumulated over fifty years. The discolouration of the varnish may not be as bad as it first appears, because of grime lying on its surface.

Before you begin, let me emphasize once again that you should *never* use water on an oil painting.

Check again that the paint film is not flaking off, then, if the picture is fairly

Fig 87 Inserting card between canvas and stretchers reduces bending of the paint during cleaning.

Fig 88 Cut stiff card to length for each side.

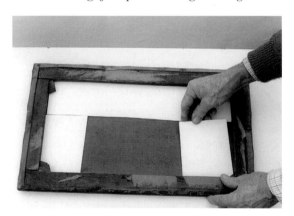

Fig 89 Do not overlap the cards; butt them together.

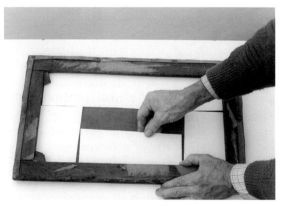

Fig 90 With all four sides inserted . . .

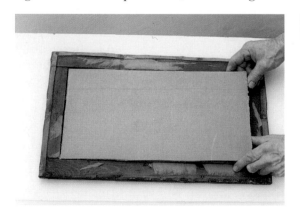

Fig 91 . . . fill up the whole back with layers of hardboard to hold the strips in place.

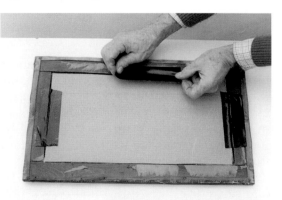

Fig 92 Use carpet tape to hold the backings secure.

recent and has few visible cracks (as seen through your magnifier), the first gentle test cleaning can be done with a small swab of cotton wool, moistened (*not* soaked) in white spirit. Keeping the picture flat on the table so that the liquid cannot dribble about, try rolling the spirit swab gently on a small, distinct but irregular area of lighter colour, for example the sky.

After approximately twenty seconds, check the result on your swab. It will almost certainly be badly discoloured as the outer layers of dirt come away, however it is unlikely that white spirit will bring off any of the darkened varnish. Nonetheless, the chances are that the wet area of the picture will suddenly appear much improved. The colours may deepen, becoming more golden, the contrast will strengthen and the details become sharper. This effect soon vanishes, though, as the spirit evaporates.

While the spirit is drying, a matter of a few minutes, turn the picture over, loosen the tapes, remove the supporting blocks and look at the test site from the rear. Here you will see proof of any cracking, for the spirit will have found its way through, staining the canvas back with lines where there are cracks. If there are only few such marks on the back, they are thin and not continuous, and there is no light showing through when you hold the canvas up to the light, you can be fairly sure that the picture can be safely cleaned again using white spirit, to complete dirt removal. Replace the support blocks.

However, if there is a thick, tangled mass of cracks, spreading right over the canvas, it may well indicate a much more serious condition. Repeat your search for possible flaking and be *very* gentle in handling the picture as you set it aside for later consideration, once you have gained

Fig 93 This typical Victorian ship and tug picture can be improved by superficial cleaning and re-varnishing.

Fig 94 Lay the work flat and wipe the surface using a cotton wool swab moistened with white spirit.

Fig 95 The discoloured swab shows the black marking of dirt being removed. Replace swabs fequently.

Fig 96 Remove the packing and study the canvas rear, which will show any penetrating spirit.

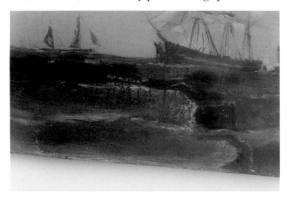

Fig 97 The dried spirit will leave unsightly smears and 'bloom' on the picture.

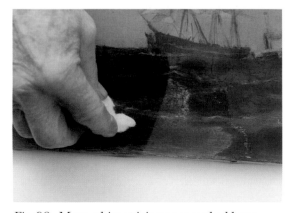

Fig 98 More white spirit removes the bloom temporarily and final varnishing will clear it permanently.

more experience.

Even two or three attempts at cleaning with white spirit may still leave the picture looking much worse than when you started as the spirit dries out each time. The dry surface will usually appear matt, smeared with thin grey or white patches called 'bloom', with much reduced colours and contrast: most disheartening.

The brightening of a picture when covered with *wet* spirit, or indeed any oily substance, is of importance in restoring, and it is essential to understand what is happening. What is changing is the reflecting power of the surface. We see colours in a painting because paint reflects coloured light, and the more effective the reflection, the more brilliant the colours and details will seem. (This is a drastically simplified explanation, of course!)

Naturally, surfaces vary in the amount they can reflect. Newly applied oil paint is smooth, glossy and reflects well. The colours appear at their best and the details are clear. When the paint dries out and gets old, its surface becomes roughened and the light falling on it will be diffused, scattered in all directions. This diffused light is wasted and the more the diffusion, the less bright the colour seems. That is the position with most old paintings.

If you spread over such a dull surface a perfectly clear liquid like white spirit this fills up the cracks and roughnesses and gives the picture, *as long as it remains wet*, a completely smooth surface. The light falling on it is now reflected in full to our eyes, none being wasted in diffusion, and the paint looks much brighter. This enables you to check the actual colours of the underlying paint. As the spirit evaporates, the effect is lost.

However, if you similarly cover the picture with a coat of clear varnish you will

see the same, colour-enhancing effect, but this time it will not disappear, because varnish does not evaporate entirely. It sets hard and smooth, so its reflecting power will remain.

VARNISHING TECHNIQUES

The first golden rule is to apply several thin coats, allowing each to dry. The second is to always work in a dust-free place, with no draughts to stir up minute particles, not an easy task, as you can see any time a shaft of sunlight falls brilliantly into a room, lighting up the floating dust. For a newcomer it is easier to use a spray can of artist's picture varnish than to apply it by brush. Choose a varnish that can be removed with white spirit (this information should appear on the can). Do not use acrylic varnish. Before the first application, make sure that your studio has good ventilation and there are no naked flames nearby. Get into the habit of wearing a filter over your mouth and nose to prevent you breathing in the spray.

Lay the painting flat on a table, surrounded by thick paper (cheap wallpaper will do) or other protection. You cannot aim spray with perfect precision, and to achieve a complete coverage it is essential to get right up to the edges, therefore some overspray is unavoidable. Point the spray down at the picture from *at least* 50cm (20in) away and press the button briefly. The aim is to let the fine varnish fall on the surface rather than be forced down on to it. A bright light directed from one side will make the spray pattern visible.

Pass the spray smoothly to and fro over the painting, working across and down for an even effect. Then leave the varnish to dry for an hour in warm conditions. Never spray in a very cold room. If the picture was very dull, this first coat will be easy to see, and very gratifying. If you have problems with dust floating in the air, turn the drying canvas over and support its edges so that there is a gap below.

After drying for two days, the last coat of varnish will be hard enough to handle and you can return the picture to its frame. A 'golden glow' will largely be the result of any remaining old varnish, discoloured over the years, but the picture will once again be protected, and many owners prefer to keep this effect. In any case, the new and old varnish can still be removed at a later date.

Fig 99 Always use a mouth filter when spraying varnish or chemicals.

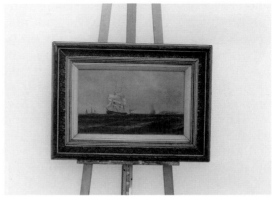

Fig 100 The painting after reframing.

Although spray varnish is reasonably effective for simple work on paintings of no special value, a more complete and stronger film can be applied using a brush. There are several keys to successful brush varnishing: use broad, high-quality brushes kept solely for varnish work; cheap brushes not only lose bristles easily, but their textures are coarse and leave visible brush marks; warm the varnish before applying it. I would say that the latter is the most important requirement. Warmth makes the film smooth and continuous and greatly reduces brush marks. Do not heat the varnish on a gas ring or electric hotplate, however. Simply stand the tin or jar of varnish in a bowl of water that is nearly too hot for your hands for a few minutes; the varnish gradually becomes thinner and easier to stir. Lay the varnish on in smooth, even strokes, clean across the canvas; then similarly at right angles, then across both diagonals. Finally, stroke off the surface in one direction only, using minimum pressure. Any brush marks should vanish before the surface dries.

Removing Darkened Surface Varnish

As you can see from Demonstration 2, removal of surface dirt and grease followed by a new coat of varnish can greatly brighten up many oil paintings. Occasionally this process may not prove successful, however, because the varnish has become irregularly patchy or turned an unpleasant colour, as in this Spanish oil on board. If you can find a similar picture, it will make an ideal first practice piece on which to gain experience.

To remove a dried, mature varnish, you must find a solvent that will soften or dissolve it and allow you to wipe it away with cotton wool. There are many solvents that would do this, so what is the problem? Quite simply that most of these solvents will remove both the varnish *and* the painting beneath. What is required is a solvent that will only remove the old varnish, leaving the mature oil glazes and paint completely untouched, and if you ever find such a solvent your place in art history will be confirmed, because so far one has not been discovered. All we have are chemicals that can be discouraged from attacking the paint below too vigorously only through skilful application and experience. Consequently, there is always some risk of injury to the painting.

I would never tell clients that 'there is absolutely no risk of damage' to a painting; I always point out that nobody can ensure damage will not occur. With care, the risk can be reduced, but when tackling oil paintings we are entering a world of uncertainty. We do not know what varnishes have been used, how often, or when. We do not know what pigments or mediums the artist has used. We do not know what atmospheric fumes may have attacked the paint structure or condensed over its surface. We do not know what grounds lie below the paint, or how these may have suffered from some form of decay. We do not know what tinkerings have already been carried out by previous restorers.

Moreover, there are many different solvents available, some cheap, some very expensive, and their reaction with the various varnishes and paints can be complex and unpredictable. A great deal of time and money is spent simply on tests if the painting is of significant value.

The above is a reminder that there are no certain or easy answers to every problem discussed in this book. Restorers have been in dispute over methods, even at the highest level, indeed particularly at the highest level! If you decide to take up picture restoration, no doubt you too will develop your own preferences.

Varnish Removal Materials

There are four main solvents that will soften or remove varnish and that you will find easy to obtain as a private buyer:

- white spirit
- methylated spirit
- acetone (propanone)
- clear ammonia.

Each of these works in a slightly different way, but the detailed chemistry is complex and not entirely understood. In practical terms, the four are arranged roughly in what I have found to be their ascending order of strength.

White spirit, also sold as turpentine substitute, will very slightly soften some older varnishes and is a complete solvent for modern varnishes. However, it does not make much headway against traditional varnishes on paintings more than fifty years old. Its effect on the paint layer beneath the varnish is almost nil in the vast majority of cases so it is a safe material to use for preliminary surface cleaning.

Methylated spirit varies in effectiveness from picture to picture. It will soften certain varnishes readily, while failing to touch others at all. Occasionally it slightly affects the underlying paint but this is not usually a problem. It is therefore another relatively safe material, and has the great advantage of evaporating away quickly.

Acetone (propanone) is a different case. This is a more complex material, a 'mutual solvent', that can dissolve materials that are soluble in water and also those soluble in oils. It can deal with varnish rapidly, and can also work away at the paint beneath if left on the surface for too long. The knack is to use it to eat away the varnish, but to stop its action, usually by applying white spirit from a pad, before it makes a start on the paint. Hasty or negligent work can easily result in damage, so be warned! Nonetheless, it is swift and efficient and is used a great deal, often in mixtures with white spirit. Some famous restorers use practically nothing else.

Ammonia is an alkali, a chemical of a rather different kind. The others soften the solidified varnish so that it can be wiped away. Ammonia, on the other hand, changes the varnish (or paint) completely, so it will never return to its previous nature. It can be applied mixed with white spirit, is fairly swift in action (sometimes startlingly rapid), but on other pictures, with different varnishes, it may react slowly. Its use does require practice and it should never be applied full strength at first, but I have found it to be most effective.

The various solvents favoured by restorers have been closely guarded secrets, but are almost always simple mixtures such as acetone and white spirit, or ammonia and white spirit. The proportions may vary, and the technical chemistry is obscure, some chemists even declaring that the slightly strange mixtures do not make chemical sense! I dare say they are right, but the practical fact is that some of them can be made to work. Since this is a book about *practical* restoration I will outline what I have found to work for me.

In addition to the four solvents listed, there are many others that might be used in picture cleaning. Some, for example petrol and ether, are dangerously inflammable – even their vapours can explode – while others are poisonous. Some need special facilities for their use and storage, or are of such high alcohol content that in Britain at least you may need a special customs licence to buy them. I have tried most of them at one time or another, and a few I do use on special work. You can try them all once you have a good deal of experience

and have read up on the technical details of each. Suppliers of specialist materials have data sheets that give all the safety information that is available. *Always read and act on these.* I would suggest that the ones to look at first might be ethyl acetate, isopropyl alcohol and diacetone alcohol, not always used alone but as part of a mixture, though other restorers might make a different selection. So many combinations are possible that the choice is practically endless.

Old Varnish

There are several different kinds of old picture varnishes, all made from various natural or manufactured resins. Natural resins are produced mainly by plants, the best for painting varnish still being a traditional one called 'Damar' (dammar) made by dissolving the resin drops exuded by the damar bush of the Far East in natural turpentine. Other resins include Sandarac, Shellac (from an insect), Copal, Mastic, and there are also many artificial varieties.

Even on a simple picture such as this Spanish oil on board, there is no easy way of telling by sight exactly what varnish has been used. It is often difficult and time-consuming to discover this information,

Fig 102 A carbon dioxide fire extinguisher is better than water or dry powder.

even by chemical and microscopic analysis. Over the years you will develop a 'feel' for the surface touch of some varnishes, but this is almost impossible to describe in words or show in pictures.

Fortunately, in normal restoration work it is not vital to know exactly which varnish has been used. What a restorer needs to know is simply which solvents will remove it. Working in a comfortably warm place, careful, systematic tests are made with a selection of solvents on small portions of the picture. The response to each solvent is noted and the best chosen for the job.

Warning! Methylated spirit, white spirit and acetone are all inflammable, and should never be used anywhere near a naked flame. Place a carbon dioxide

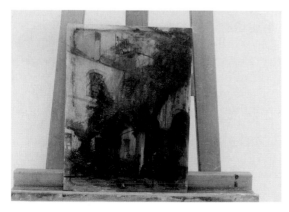

Fig 101 Oil on board of Spanish buildings, heavily darkened by old varnish.

(CO_2) fire extinguisher, coloured black, near the door of any room in which you are using these solvents. Test it regularly, whether it has been used or not. Do not rely on any other sort of extinguisher; water may spread the blaze, while dry powder will smother everything in fine dust.

Some form of magnification is essential, preferably one that leaves both hands free, such as this cheap stand lens which is suitable for small pictures.

If your eyesight is good, a cheap plastic sheet magnifier will suffice. This gives binocular vision, which I feel is better for the work as varnish is often humped up from the surface. The ideal tool, however, is the binocular headband. This prevents the magnifier from getting in the way of your hand work. During the work small swabs of cotton wool wetted with solvents are used. Never use such liquids on a painting stood upright on an easel because if they dribble the mark they make can be very difficult to remove. Instead, always lay the picture flat, or very gently sloping towards you.

It is always best to avoid resting the hands on the surface of a painting. You can make a shield of thick card, with a working hole cut through and strips of foam draught excluder on the back.

DEMONSTRATION 3 – REMOVING OLD, DISCOLOURED VARNISH FROM AN OIL PAINTING

Choose a small part of the painting, preferably a light area near the edge of the painting, away from the important images. Do not carry out a test in the middle of the face of a portrait, for example (though I have seen this done), and avoid testing in neat, tidy shapes such as parallel strips or squares. If you make a mistake and take off too much varnish or paint, it will be easier to blend in and correct an irregular area.

Fig 103 A stand lens is a useful study aid.

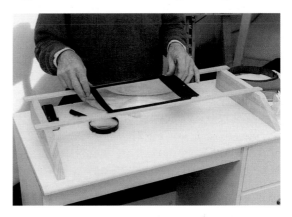

Fig 104 A sheet magnifier with improvized stand is excellent for normal working.

Fig 105 A hand rest made from card keeps moist or greasy hands hands from touching the picture

Try the four main solvents, each one on a separate patch. Use white spirit for your first test area and, if this is unsuccessful, follow on in a new test area with methylated spirit. Moisten a small cotton wool bud in solvent, then roll it steadily back and forth over an inch of the painting, counting the number of rolls. Do not scrub the surface. The solvent should soften the varnish and it should then be picked up on the cotton fibres by its own stickiness. Make twenty rolls at at a time, keeping an eye on the cotton wool for any sign of discolouration. Grey or black marks on the bud will simply mean that ordinary dirt is coming off, while yellow or brown marks are traces of softening varnish. Make a note of the number of rolls at which this occurs. Stop the rolling and let the spirit evaporate. However, if there are no such traces after about a hundred rolls, move on to a more powerful solvent, acetone, for your third test patch.

Note Before attempting a test with acetone, prepare a 'stopping pad' – a thumb-size pad of cotton wool soaked in white spirit, then squeezed out to be uniformly moist. Make a well-stirred mixture of three parts white spirit to one part ace-

Fig 106 Using a cotton bud with solvent to roll away varnish.

tone, and roll it on with a cotton wool bud as before. Be wary of this solvent, as it sometimes works rapidly. Make sure that drops do not fall unnoticed on other parts of the picture. Roll steadily and evenly and watch for the slightest signs of varnish being removed and staining the swab. If this happens, stop the action immediately by dabbing the stopping pad over the wet patch. The spirit dilutes or displaces the acetone still further and stops the action. Then dab the surface dry with fresh, dry cotton wool. Note the number of rolls it takes to bring off the first traces of varnish.

If the acetone works, but only fairly weakly, you may decide to strengthen the mixture to speed up the action. If, however, it does not act effectively at all, there still remains what is often the most efficient solvent of all – ammonia.

Do not use ammonia straight from the bottle. I have found that a mixture of one part ammonia to two parts white spirit, freshly made and well stirred or shaken, acts fairly swiftly if it is going to work at all, so start with this ratio. Apply the mix with a cotton bud as before, but look at the bud after every roll for traces of removed varnish. Again, take great care not to drop any ammonia on the painting. Sometimes the initial effect of ammonia is so great that too much varnish is removed and there may be traces of the underlying paint on the bud after only two or three rolls. If you get such a rapid response, quickly kill the action with the stopping pad and then dilute your ammonia mixture by doubling the amount of white spirit to four parts to one. This will slow the reaction speed considerably for further trials. Of course, if a dilute mix has no effect at all you could reduce the amount of spirit or even use the ammonia alone, but be cautious as this sometimes wipes varnish away with great speed! I have rarely needed to do this.

Ammonia is certainly very effective, and does not leave certain traces in the paint-work as the other solvents may, but it can still affect underlying paint if it is over-done. Rubbing too hard with it may not only remove every last trace of varnish, but can also 'skin' the picture surface, leaving it rough and worn-looking, with the bare canvas texture showing through. It is bet-ter, as always, to remove too little than too much.

It is time-consuming to make all these tests, but the process is vital. Indeed, it is in the selection of solvents that the skill, or incompetence, of the restorer shows itself. Take nothing for granted when removing varnish. After making tests on several pic-tures you will begin to realize how varied they can be. Some pictures that appear very similar, even painted by the same artist, can respond in surprisingly different ways. Different varnishes may have been used in different areas of the picture due to earlier restorations. It is easy to re-apply solvent if not all the varnish comes away, but it is very difficult to replace underlying paint removed by overenthusiastic application.

Once the solvent is selected you can get to work. Do not start on the most interest-ing, detailed area of the picture. Instead, choose an area that is relatively unimpor-tant and preferably light-coloured. In a landscape this is usually the sky, while on buildings it would be the higher, better-lit areas.

Work over a small part of the painting that has a distinct shape, such as a house wall, rolling the varnish away within the selected area. Try not to take every trace of the varnish away, but leave a little behind. If possible, match the colour and tone of the original paint showing at the edge.

Continue into adjacent patches but watch your swab carefully for any appear-ance of colour, as opposed to the

Fig 107 Start on a defined part of the building.

yellow-brown varnish stains, as this is an indication that actual paint is being removed. Stop rolling immediately.

Apply a stopper pad of cotton wool moistened with white spirit and move away to another part of the picture. Work irreg-ularly, cleaning the natural shapes on the painting and avoid working in straight lines, unless these are part of the design. Precise, geometric shapes are hard to blend together as the painting gradually lightens, and often remain visible long afterwards. I have seen restorations in which the mechanically parallel lines of cleaning can still be seen, particularly in the sky; had they been irregular, perhaps following the contours of the clouds, they would have been completely unnoticeable.

Gradually you will get the feel of the var-nish. With practice, it becomes quite easy to tell when the last of the varnish has been removed, simply by the change from a faintly scratchy, dragging effect on your fingers holding the cotton wool to a smoother, easier flow as the swab reaches the paint below. Notice how details such as shadowy figures leap into view.

As you move lower into the (usually) darker foreground, it is not as easy to see what is happening. If dark paint has been

Fig 108 If the swab shows any sign of coloured paint, stop work . . .

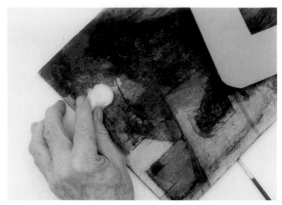

Fig 109 . . . and kill the operation of the solvent with a stopper pad of white spirit.

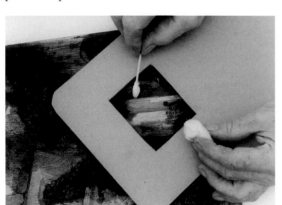

Fig 110 Fine details may suddenly appear from the dark shadows.

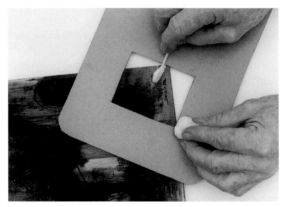

Fig 111 Take great care near any signature – leave it rather than remove it!

used, the varnish will not make much difference so there may be no obvious visual change to tell you that it is all gone. Remember that the varnish will almost certainly be the same depth all over the picture, so use no more rollings than you did on the sky. Take particular care with signatures. It is better to leave them uncleaned than to remove them.

Some of the darker paints, especially greens in older paintings, seem to dissolve more easily. Watch your swabs carefully and change them frequently. I rarely use a bud for more than five minutes. My studio floor rapidly becomes a sea of cotton wool bits, and so will yours, but cotton wool is cheap compared to the value of the work you are doing. The paint surface will still look unsatisfactory, even quite unpleasant, at this stage, however, and may well be dull, rough, matt and dry. There may be streaks of brown or yellow in the lighter areas, while others may have larger patches of stubbornly clinging old dark varnish. More work is therefore needed to complete the cleaning and restoration process.

Nonetheless, if a fairly thick layer of varnish has been removed, the transforma-

tion will be surprising. The whole scene may be transformed, perhaps from a stormy day to a bright summer afternoon! Some newcomers to restoration are unnerved by this dramatic alteration and wonder whether they have accidentally removed some paint. This is possible, but unlikely. The effect of dark varnish is enormous and you can expect an equally enormous change.

Finally, working slowly, inch by inch, cover the whole surface, removing all the areas you missed. This precision work is perhaps the most demanding of all, because you will be in the frame of mind that the job is nearly done, so why take the time to look for tiny defects? Personally, I mentally 'grid' the work into small squares, concentrating on each one as if it were the last, as, eventually, it will be!

Do not try to remove any remaining stubborn streaks by rubbing harder and harder, as this may well grind down deeply into the paint nearby, long before the ridge of resistant varnish is scoured off. Instead, try removing the streaks with a scalpel. Fairly cheap sets are available with different blades, one of which is a forward-facing blade like a little flat shovel. Hold this

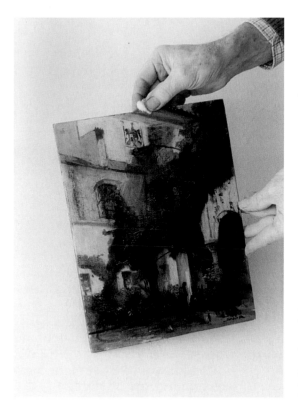

Fig 112 The whole painting as the principal features become clearer.

Fig 113 Now the picture is ready for fine detailed cleaning.

Fig 114 The completely cleaned work is sparklingly different.

almost parallel to the paint surface and thrust forward with gentle downward pressure along the length of the streak. The action resembles that of a gardener's Dutch (push) hoe. The varnish is pared away in very thin layers, leaving the paint surface itself undamaged. If the surface of the painting is rough, with pronounced brush marks, this flat scraper will not get into the 'valleys'. Change to a blade that is angled and hold it nearly vertical to the surface. Use a scraping action. If the tool makes too sharp a scratch, grind its tip until it is more rounded. Attacking a masterpiece with a sharp blade may seem a perilous task, but used gently and patiently it is one of the safest methods of varnish removal. Sometimes I use it exclusively, particularly if I have any doubts about the resistance of the underlying paint to solvents. The one great disadvantage of the method, however, is that it is very time-consuming. Consequently, removing all the varnish manually is an expensive undertaking for a client. The results though, can be excellent.

Another technique occasionally used by artists is to apply a varnish, then to use its smooth surface to apply extremely fine details such as masts and rigging lines on old ships, finally applying another varnish coat on top.

These lines therefore were sandwiched between two layers of varnish, so if you remove the discoloured varnish during the cleaning process, the fine lines vanish too. An adequate solution to this problem has not yet been discovered. I tend to work inwards up to the lines but leave the varnish on them in place. I don't always succeed, however!

Finally, wipe over the whole picture with white spirit and apply varnish. You may find that you have to apply several coats to get an even finish. Even then, some parts may not become glossy. This is a well

Fig 115 Thin lines may be sandwiched between varnish coats. Work up to them from the sides if this is suspected.

known and not clearly understood problem often called 'drop out'. I have no general solution to offer, except to say that if you allow the varnish to dry well between coats, matters generally do improve. Adding several heavy coats straight away seems to be an unsuccessful method.

At last, all is completed. You may find that some of your work looks spotty and ragged, some areas scraped and bare where you were too enthusiastic with the solvent. Do not worry. It takes time to become a professional, but you have completed your first varnish removal. Look back at the photograph you took at the beginning of the process and take a final photograph of the completed picture.

CORRECTING COLOUR CHANGES IN MEDIUM AND PIGMENTS

There are two ways in which the colour of a paint may change after it has been applied. The first is a yellowing and darkening of the medium itself, causing a general colour change over the entire picture. The answer to this problem is simple – there isn't one! No chemical approach is

going to rejuvenate a mature medium that is actually in place. It was this change and the darkening of varnish in old master paintings that was behind the famous statement of Sir Joshua Reynolds that 'a good painting, like a good violin, is brown'. I have actually achieved a slight change using a very thin glaze of a complementary colour, somewhere in the purples, on a area in a painting where the yellowing was objectionable, but this was at best a compromise.

The second is the fading of the colour intensity of the pigments by the action of light, damp or chemical change, causing a washed-out, weak appearance. You can check whether this has occurred if the frame overlaps and has protected the edges of the painting, as here the colours may be nearer their original strength. Again, the answer is that there is no way to bring back faded colour in pigments. All you can do is overpaint them, either with new body paint or translucent glazes, and this is only done where the picture has a purely personal appeal to the owner, and is of no serious significance. Painting on top of original work, no matter how faded it is, is not considered an ethical practice with works of art, and should never be carried out if the picture is at all valuable.

However, in spite of this, I have seen many paintings that have in fact been judiciously 're-touched' to produce a more appealing appearance for potential customers.

Although rare, yellowing of flake white and a few other lead-based pigments in old oils can be caused by exposure to sulphur in the past, perhaps from open fires. If the whites of an old painting appear suspiciously yellowed, the rest of the picture being unaffected, apply hydrogen peroxide, painted on carefully with a fine brush which will, if successful, lighten the paint within a few minutes.

REPAIRING CREASES, GASHES AND HOLES

You will be glad to hear that repairing creases and holes in canvas or board is not difficult. You will need to take care, and the work does require patience, but you should soon be turning out reasonably good results.

Small holes or missing pigment patches are common in old paintings, They are rarely serious in themselves, but often hint at bigger troubles! An isolated hole up to 3mm (⅛in) wide in a canvas, or 25mm (1in) wide in a board, can simply be filled with a paste, putty or solid acrylic paint. A useful material is acrylic modelling paste, available from art suppilers. This is essentially ordinary acrylic medium with powder content to make it heavily viscous. It is strongly adhesive to wood, much less so to dried oil paint, and remains flexible after curing. Simply thrusting it into canvas holes from the rear and allowing it to set in contact with their frayed edges will provide a plug secure enough to sandpaper flat and colour with thin acrylic paint to match the surroundings.

You can make a good, traditional stopper for larger holes by buying a small bottle of stand oil from an art supplier and mixing this with whiting or powdered chalk, rubbing it from a soft, sticky mess to a stiff but still plastic putty by gradually adding powder. Make white or coloured putty by adding any colour of powdered pastel. Work it into the hole, leaving it slightly proud of the surface. As the putty dries you can model its surface with pressed-on canvas and so on to match the general texture of the surrounding paintwork. Allow the plug to set and finish it off with acrylics.These will only bond moderately with the oil-based putty, making it easier to alter the colour later, if necessary, without

Fig 116 Applying basic filler to a damaged oil on board.

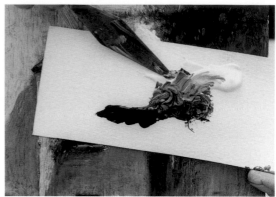

Fig 117 Always use easily-cleaned knives rather than brushes for precise colour mixing.

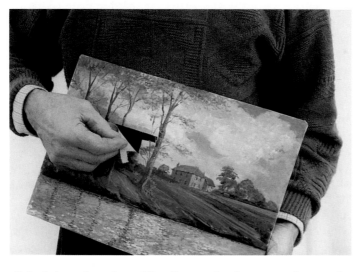

Fig 118 This impressionist acrylic is typically torn along the weave. Its low value makes patching the best repair.

dislodging the plug. Finally, apply the surface colouring in acrylic. Start with too light a colour on a slip of card set beside the plug, and darken it gradually. Dry the card with a hairdryer. Compare the dried paint with its surroundings, adding a swift coat of white spirit to both to bring out the final, varnished colours. Then apply the chosen colour. Do not extend beyond the plug area to 'blend in' the new paint as you will end up spreading it further and further.

Putty, commercial texture-paste or even several layers of acrylic paint alone can all be used on boards. Where damaged wood is exposed, first apply a thin layer of oil-based varnish to prevent the re-touching bonding too tightly so that it can be easily removed.

Carefully mix the desired final colours or tones. Always use metal paint knives to mix colours for matching, as they can be instantly and completely cleaned by the wipe of a cloth. Brushes are hard to clean and retain traces of previous colours that make accurate mixing impossible.

In principle, a wide canvas hole or split is drawn together and a patching piece glued

underneath. The adhesive must be strong enough to withstand the tension of the canvas when in its stretchers. At the same time it must remain flexible after curing so that the movement of the canvas as it swells and shrinks with changes of season does not cause it to crack away. However, even professional repairs are often clearly visible from the front of the painting, because the canvas next to the patch slightly shrinks with the glue, pulling it downwards and outlining the edges of the patch. This is especially noticeable if the patch is a regular, straight-edged shape. Making the shape and its edges flexible and varied in shape will help to conceal it.

In the past, actual glue was used to stick patches in place and canvases together but this often proved too brittle and would crack because it could not flex with the canvas. A better material was found to be a beeswax/rosin mixture, two parts beeswax to one part rosin, with a half part of Venice turpentine, prepared by melting the wax and rosin together in a pan over a hotplate and adding the turpentine later, away from the heat source. Patches made using this are still perfectly sound after a hundred years. Rosin is made from turpentine and a natural resin. There are many other resins, some natural and others artificial, that can be used similarly. You can obtain suitable materials from conservation suppliers, and I use it for most such work. There are new, ketone resins that work excellently instead of the traditional rosin, and the costs are small.

I also do a lot of work, especially where precise positioning is required, with a superb adhesive called BEVA. This is heat activated, supplied in tins, and can be thinned down with naphtha for various uses. Applied to two surfaces that are then allowed to dry, it is not adhesive and parts can therefore be adjusted freely. When warmed, it becomes as tacky as masking tape, and if pressed with a warm iron it will liquefy and fuse the canvases together, cooling in minutes to a strong hold. If you get the positioning wrong, simple warming allows you to pull the bits apart and try again, or you can remove the BEVA entirely with naphtha or white spirit. BEVA is an ideal material for use by a newcomer. Keep your work room ventilated though, as some people are sensitive to its fumes. Always read the label.

DEMONSTRATION 4 – PATCHING A TORN CANVAS

Cut out a patch of thin canvas, at least an inch larger than the hole or slit. The ideal shape is one that follows the outline of an image on the picture itself. Then feather-slit the edges with closely-spaced points.

Make sure the solid centre of the patch will cover the hole, then coat one side in wax resin or BEVA adhesive, taking care to cover every point.

Lay the canvas on silicone release paper over a smooth, flat surface, and apply BEVA or wax resin to the rear of the canvas where the patch will fit. Make sure that you cover the entire patch position with a little to spare.

Lay the patch in place. You can use a tacking iron to hold it temporarily.

BEVA and wax resin are both heat sealed. Use an iron set to low heat, no more than a nylon setting, and press down firmly through silicone paper on to the patch. Only a few seconds are usually needed, and it is simple to repeat the pressure if adhesion is weak. If you are patching an oil painting, start with a very low heat setting, and pad the work table with a layer of carpet felt under the canvas.

Finally, inpaint the face of the picture to conceal the work. It is a useful practice to make several different-sized holes in an old, valueless picture, to gain experience in using this technique.

Fig 119 The large, irregularly shaped patch is 'feathered' at its edges.

Fig 120 Make sure the unfeathered part covers the hole completely.

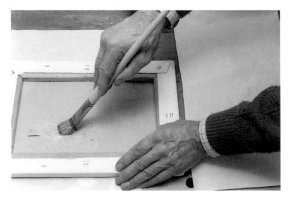

Fig 121 Apply adhesive to canvas and patch. Allow to dry.

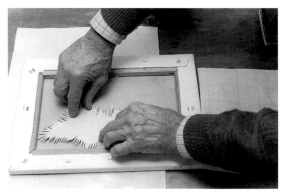

Fig 122 Lay the patch in place with care. A dab with a hot iron will hold it temporarily.

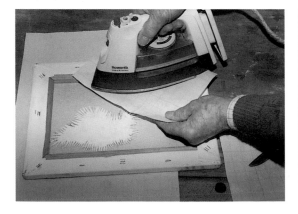

Fig 123 Iron the whole patch through silicone release paper. Great heat or pressure is not needed.

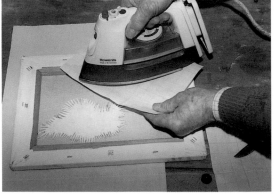

Fig 124 Inpaint the repair, with oil paint if the picture is valuable, with acrylic if not. A coat of varnish will blend the repair in well.

DEMONSTRATION 5 – LINING (RE-LINING) A PAINTING

Most older paintings have more than one problem that requires work. Over the years all canvas deteriorates and becomes subject to thread weakness; several slits and holes may appear; parts of the paint surface may be cracking; and it may become impossible to maintain the tension on the stretchers necessary to keep the picture flat, because this pulls weak canvas edges apart. For centuries a common practice has been to glue such paintings down on to a second, fresh canvas. The work used to be called 're-lining', but 'lining' is the correct term.

You will need an oil painting of little value, with holes, tears and poor fastenings. This little oil painting was in just such a state and would be an ideal practice subject for a newcomer to the work. If you cannot find a picture with holes already present, you can always make your own!

First, clean the surface dirt and remove any old varnish, as described, but do not re-varnish at this stage.

Note carefully any writing that may appear on the canvas; if possible take a photograph. Use a curved tack-lifter to remove any embedded nails securing the

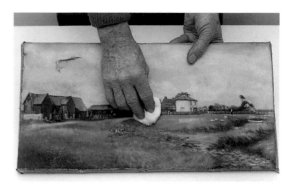

Fig 126 Start by cleaning with white spirit and urgent varnish removal. Leave final work till completion of lining.

Fig 127 Use nail lifter on a thin metal support to remove tacks without damage to canvas.

Fig 125 Some pictures have multiple damage and full lining is best.

Fig 128 Examine all tears. Trim frayed threads to prevent them being trapped below lining canvas.

canvas. Insert a metal blade below the tool to spread the pressure on the canvas edge.

The hole in the canvas could be dealt with separately, but will now simply form part of the lining process. As the work is done, keep checking that the frayed edges are kept together and loose threads are not turned under.

The edges of the canvas will be damaged where the tacks were embedded. Brush out any dirt present as these will affect the adhesion if left. Do not use water.

You may find old patches or repairs, sometimes made with traditional putty. Really secure putty spots can be left in

place, but do sandpaper them perfectly flat and level with the canvas at the rear. If any are loose, remove them completely.

Remove all previous patches, even if you re-expose the holes they filled. Warming them with a tacking iron may help their removal; if they were applied with wax-resin adhesive they will then easily peel free.

If there is any sign of the surface paint cracking, any flakes that might fall away must be held in place. Lay the canvas face-up on a sheet of silicone release paper and paste a 'facing' of several sheets of tissue paper over the entire surface, using a water-soluble conservation adhesive. (For

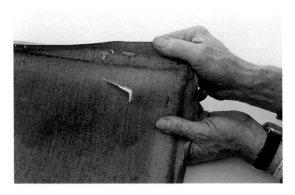

Fig 129 Check similarly for torn nail holes at the edges. The paint here may be fragile.

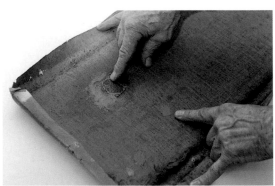

Fig 130 It is best to remove previous repair patches.

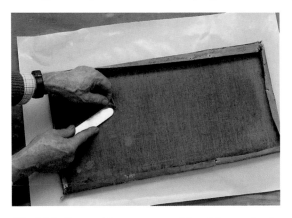

Fig 131 Scrape them away with a blunt-edged palette knife. Do not use solvents or water.

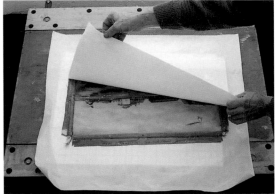

Fig 132 To prevent surface paint flaking away, paste to the picture face several layers of clean tissue.

your practice pieces, use thin wallpaper paste.)

Make certain this paper is pressed and tamped down well into the irregular impasto of the painting, and that it sticks to any opening splits in the canvas. Although such 'facing' is not always essential on a sound paint surface, I recommend that you always apply it. Paintings are unpredictable and flaking can happen at any time, usually at an awkward moment.

To fasten the canvases together you can use beeswax/rosin or BEVA adhesive. Apply it warm and fluid, brushing it rapidly and evenly over the entire rear of the painting. Make sure you get right to the edges and under the curls of any slits and holes.

Similarly, apply adhesive to the new support canvas. Some restorers use sized canvas as support, but I prefer plain cloth.

Working with an iron set low, no higher than the nylon setting, press the sandwich of canvases together through a sheet of silicone paper. Start near the centre to avoid trapping air. At this stage you are distributing and re-warming the adhesive. Over two or three more pressings, gradually increase the pressure, but heavy weight is not needed.

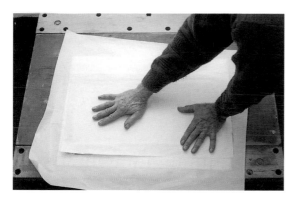

Fig 133 Press this paper well down into the irregularities of the surface.

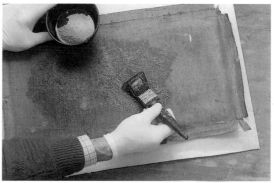

Fig 134 When the facing has dried, apply adhesive to the picture canvas

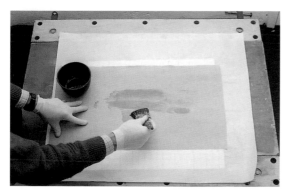

Fig 135 Similarly apply adhesive to the new canvas.

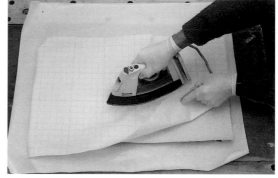

Fig 136 Working from the centre, iron the sandwich together. Use firm but not heavy pressure. The work is easiest with smooth face paintings.

Transfer the work to your press or clamp boards and allow it to cool completely; these prevent it curling. On removal you can easily check whether adhesion is complete. A great advantage of these adhesives is that if all is not well you can simply warm the whole sandwich up again and peel it apart to have another go. (If the painting had been larger, I would have used a canvas five inches wider all round, and previously stretched it over a wooden frame. Like the press, this prevents the combined canvases curling up on drying.)

Remove the facing paper by moistening and peeling it away. Do not soak it or the picture may be damaged.

Remaining traces of adhesive, including any that has been forced up the cracks, can be removed with white spirit or solvent naphtha. Again, do not flood the surface or the adhesive may loosen.

Trim away the surplus canvas, leaving sufficient to wrap round the stretchers. The doubled thickness means the corners will be bulky if folded. Cut away a square at each corner to allow folding of the edges.

The surface cracks, if small, are most easily rendered unobtrusive by applying matching pastel powder to each area and

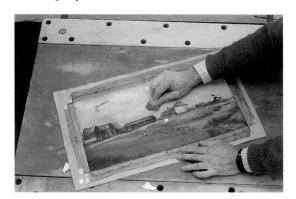

Fig 137 Cramp the work at once between rigid boards if a press is not available

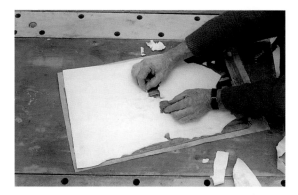

Fig 138 Removing facing paper by moistening and gentle scraping.

Fig 139 Wipe the paint clean with white spirit or solvent naphtha (the solvent for BEVA) to remove adhesive forced up to the surface.

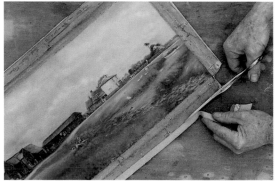

Fig 140 Trim the new canvas to size for re-stretching.

gently rubbing over the surface with a finger and soft brushes. This will largely fill the cracks, and any surplus on the surface is blown away.

A spray of pastel fixative will hold the powder in place until the varnishing is complete.

When you have inpainted the tear at the left of the sky, cleaning can be completed and the whole picture given a coat of varnish. Final varnishing is done after the painting is replaced on its stretchers.

This practical method of lining will serve in most cases, but do remember that performing one successful lining will not enable you to tackle your neighbour's old master. Do not expect too much of yourself. Every restorer is learning all the time, and pictures can be complicated and infuriating things. Perform several practice linings before you tackle your first 'real' one. My demonstration picture was originally painted fairly smoothly, and had only minor flaking. Do not carry out your first attempt on a painting that has a heavy, deep and irregular impasto, as this can easily be crushed by the iron, or on a painting that is losing paint in flakes. Hand processes do not always produce results that last as well as vacuum press work, but they do

Fig 141 Matching soft pastel tested on a finger . . .

Fig 142 . . . and gently rubbed into cracks in the sky area . . .

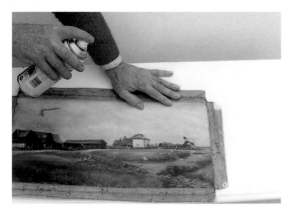

Fig 143 . . . can be secured temporarily by spraying with pastel fixative.

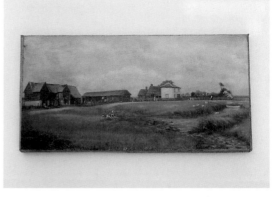

Fig 144 The result is a well-reinforced picture with a long life ahead!

serve as a good protection for low-value pictures that would not warrant the cost of professional restoration.

SECURING CRACKING OR FLAKING PAINT

We are now entering dangerous territory. After all, if a painting breaks up and falls from its support there is usually little that can be done to help. If it were a masterpiece worth millions, you might attempt a few years of patient, aggravating work, but this is unlikely to occur. The important thing about cracking is determining whether it has become stable, and therefore reached the peak of the damage, or is still unstable and progressive, so that every passing year sees more damage and more risk.

Stable Cracking
This is mainly in the form of craquelure, the long-term drying out of mature paint film, usually valued as a benefit rather than a matter for restoration. Do not attempt

any work on such pictures, for they are almost certain to be of significant value.

On younger paintings the cracking of the paint layers beneath the varnish may still be relatively stable, and less complex in pattern. The causes may be many, the most common being incorrect painting methods and treatment, particularly failure to varnish the work after completion, hanging the work over heat or storing it in damp places. Provided the paint is not actually coming away completely, some reinforcement can be given, though nothing can compensate entirely for such failures.

As shown on page 87, you can brush cracks with pastel powder and apply spray fix and varnish, which will improve the appearance slightly. You can also use acrylic medium as a stabilizing varnish. This is actually a real glue and can get into cracks and hold the flakes together. A top coat of Damar oil varnish will then return the picture almost to its original oil-painting appearance. Acrylic, however, is not

Fig 145 Cracking can gradually lead to flaking off. The earlier repair work is done, the easier it will be.

easy to remove without ruining the picture. Such a permanent coating should never be applied to any work of significant value. A picture that has undergone either of these treatments should be marked on the back with the details, so that any future restorer will know that the varnish is also acting as an adhesive.

If much of the painting is affected, a better result can be achieved by facing the front of the canvas with pasted-on protective paper and applying warm, heat-sealing adhesive with a flat iron to the rear side, exactly as described for lining. Your aim is to melt the adhesive under steady pressure until it has penetrated right though the canvas to grip the paint flakes from below. Work outwards from the centre, increasing the heat very gradually if the adhesive fails to melt. On removing the facing, adhesive may be seen on the painting. Remove this with white spirit.

Imitation Craquelure Varnishes You may come across much younger paintings, usually of poor quality, which have a craquelure that, on careful inspection, is coarser in pattern and is obviously in the varnish only. It will not usually be flaking away. This may well be the result of a deliberate attempt to imitate an ancient cracquelure, either by cooking a newly-applied paint or varnish in an oven, or by applying a varnish specially formulated to break up on drying. These are sold as 'antiquing varnish' and are often made pale brown to enhance the aged look. A restorer who was known to use these methods would lose every shred of respectability. These varnishes can be removed with the usual solvents.

Unstable Cracking

Unstable cracking is when the paint surface is definitely breaking up into tiny flakes that fall off. When seen through the glass, if the flakes are still attached to the ground, their edges may be starting to turn up, rather like tiny tea-trays. A characteristic fault is the appearance of tiny flecks of white where the flakes meet and their corners have broken away. There may be spaces where one or two flakes have already been completely lost, while in the worst cases whole patches of the painting may have vanished.

If the surface as a whole is fragmenting like this, it is a very serious condition, and you should not try to correct it in a valuable painting until you have gained experience on less valuable paintings. This is not easy, because even rather poor old paintings are becoming more and more valuable as time goes on, simply because they are rare. I cannot recommend that you practise this work unless you own such a picture, and clearly understand that success is unlikely, especially on your first attempt. Even if you do achieve success, do not imagine that you can now treat any picture that comes your way. Every painting is slightly different. The degree of flaking may seem the same but the adherence may be much less, while some paint layers simply do not respond as you expect. An experienced restorer will recognize any problems that may arise before matters have gone too far.

The safest method of restoring flaking paintings is to place them in the hands of an experienced restorer who has specialized equipment, particularly a heated vacuum table. This is a worktop covered by an airtight sheet that is sucked down on to any painting laid underneath it by an air pump. The pressure is completely even, the painting cannot shift and the temperature can be controlled exactly. Such a tool is very expensive, and not all restorers do enough of this type of work to warrant owning one, but it does enable many

sophisticated and permanent methods and adhesives to be used.

Certain hand methods can be reasonably successful, if carried out with care, experience and skill, in which the heat and pressure are applied by less expensive tools. Such approaches are outlined below, but it is a condition that in most cases really calls for a professional.

REMOVING CREASES AND DENTS IN CANVAS

Cracking may occur when a canvas has been stored wrongly, perhaps leaned against a sharp point, so that dents or creases have been formed in it. These may be quite pronounced and very distressing to see. To remove the humps, lay the picture face-down and moisten the area of the actual depression (*not* the surrounding canvas) with white spirit. Apply enough to darken the canvas, then leave it alone. If it is kept still and level it will usually dry out in a day and shrink the hump flat. If the damage was fresh, the cure is often complete in one application, but you can repeat it as necessary. This works just as well, sometimes better, with water instead of white spirit, but it is always risky to wet oil paintings.

If the damage was at the back, the paint layer itself will not usually require repair because any slight cracking will be 'opening cracks', which will close up again once the canvas levels out. When the canvas is dented inwards from the front it is a different matter. The paint will have 'closing cracks', with the paint flakes crumpled together within the dent. Study the damage closely. Some flakes may still be partly attached, and a trace of wax resin or other adhesive can be applied under these with a brush or hypodermic needle, then gently pressed down.

Some pieces may have fallen off completely. Collect these together and sort them out on a sheet of white card. Try to re-build them into their original pattern to find where they came from. Coat the canvas space and the backs of the pieces with BEVA adhesive. Leave them to dry, then manipulate the bits into place. There may still be spaces or some loose pieces that simply will not fit, but do the best you can. Gently press each piece with a warm tacking iron. This will melt and re-activate the BEVA. This adhesive can be warmed as many times as you like as you juggle with the pattern. If need be, you can remove it completely with solvent naphtha and start again. Finally, fill in any missing paint and cracks with matching acrylic paint (*see* Chapter 14).

Repairing hump-damaged flaking is good practice for use on larger areas. On these, if the flakes are still attached and the cupping of their edges has not progressed far, it is just possible, under magnification, to apply BEVA adhesive with a hypodermic needle or the tip of a very fine brush slid under their curled edges.

You can then roll the flakes gently flat with a tiny spoon-like heated spatula. Specialist firms supply tacking irons for professional use, but good results can be achieved cheaply by clamping part of a stainless teaspoon to an ordinary low-voltage electric soldering iron. Hold this just clear of the flake at first to soften it. Some restorers have a cold spoon in their other hand to press the soft flake down. Rock the tool slightly, side to side and lengthways, to 'iron' the warmed flake back down to the canvas. All too often, however, the flakes simply do not soften or else you touch them directly with the tool, they stick to it and come off altogether. If this happens, they may even fall off and stick down again in the wrong place, making a

Fig 146 A heated tacking iron can be bought custom-made or improvized by clamping a stainless spoon to a soldering iron.

little lump and an associated little hole in the paint. Other bits might fall to the floor to be lost forever. The procedure is apparently simple, yet in practice it calls for endless patience, as do so many restoration jobs!

A gentle flow of warm air from a heat gun or hairdryer applied *underneath* the painting can also help the flakes to soften, but the temperature is hard to control. What you want is a flexible paint fragment that can be 'ironed' flat, but that is not melted on top. If this can be achieved, the flake will often stay in place after pressing. If it does shift, it will still be visible lying on the surface and you can nudge it back into place and try again.

TREATING MOULD AND FUNGUS ATTACK

This can be mild or devastating, but should never be neglected. The effect is mostly seen on the support, whether wood or cloth, and the cause will almost certainly include being hung on a damp wall, or kept in damp storage conditions with poor ventilation. The worst appearance will probably be at the rear of the painting, in the gap between the stretchers. Fortunately, much of the frightening growth that is sometimes seen can be dried, brushed and dusted clear. As always with paintings, do not use strong heat.

Moulds hate sunshine and I have achieved good results merely from expos-

ing the rear of such canvases to several days of direct sunlight. I am wary of applying water solutions to canvases, but have sometimes used a swab of cotton wool to wipe on a 10% solution of magnesium silcofluoride, which was allowed to dry and then wiped off with a little plain water. It is difficult to know how protective this has been over the years. Commercial spray fungicides can be used, and more are in development; suppliers of restoration chemicals can advise on these. Do not use domestic fungicides.

'Blooming' is an area of misty white appearance, sometimes associated with restoration work, but which can occur on a picture on a wall, often where damp is a problem. Its actual cause is a source of dispute, but may be fungal. One treatment for bloom on a smooth, soundly varnished picture is a cotton wool swab moistened with very thin, light lubricating oil, of the kind used for sewing machines. Rub this gently over the surface, inch by inch, and then polish off well with clean, soft cotton wool. The object is to leave behind a very thin coating of the oil. Test a small area first. The effect may recur, but this should cure it for a time.

DEMONSTRATION 6 – RE-STRETCHING A CANVAS ON STRETCHER FRAMES

The little riverside oil could easily be re-fitted to its old stretcher using its original tacks, however you often have to stretch a canvas over new stretchers. This has to be done in a particular manner if the result is to be an evenly stretched, perfectly accurate rectangle. For this demonstration I have used a thin, plain cloth so the folding can be seen more easily.

The four wooden stretcher sides interlock with slotted joints at each corner. There are also slots in each corner for the

Fig 147 Stretcher corners slot together easily.

Fig 148 Round off the stretcher ends to reduce stress on the canvas corners.

Fig 149 Check carefully for squareness in assembly, using setsquere . . .

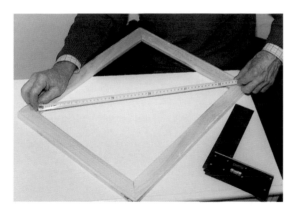

Fig 150 . . . and by measuring the diagonals. If these are equal, the corners are right angles.

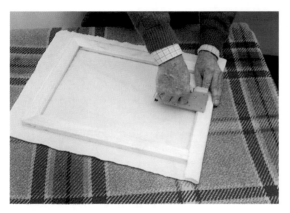

Fig 151 Start by placing a staple in the centre of one short side . . .

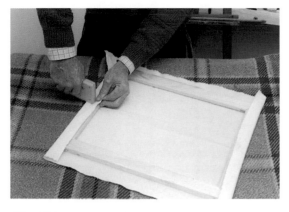

Fig 152 . . . and the centre of the opposite side.

insertion of expansion wedges, but do not insert these at first.

Assemble the four sides, pushing the mitres firmly together and rounding off the corner smoothly (sharp corners can eventually penetrate the canvas).

Make sure the corners are right angles, perhaps by holding them against a door frame, or using a large setsquare.

As a final accuracy check, measure the diagonals, corner to corner. When the frame is correctly squared, these two measurements will be identical.

Cut the canvas 125mm (5in) larger each way and place the frame on it. Pull the canvas over the middle of one of the shorter sides and insert a staple or tack. Staples from a gun are far easier to fix than traditional tacks, which require two free hands. For large, important work, I still prefer traditional tacks, however.

Then, similarly fix a second staple in the middle of the opposite short side. Test again that the frame is square.

Draw both longer sides of the canvas over their stretchers and staple in place in the the middle.

Continue adding staples, first along one half of one of the long members to within four inches of its end, and then along half of the opposite side. Continue along half of each of the shorter sides. Finally complete the whole of all sides, keeping the canvas evenly taut and the corners free. Check squareness at intervals throughout the work.

It can be difficult to fold the canvas at the corners. It is important to get this right or it will also be difficult, perhaps impossible, to expand the stretchers with their wedges. Follow the step-by-step instructions and practise the procedure several times.

Pull the canvas corner back diagonally over the stretcher joint and insert one staple.

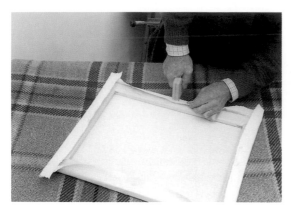

Fig 153 *Staple all sides outwards . . .*

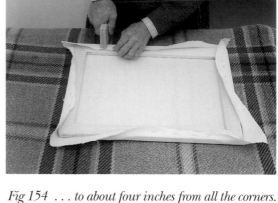

Fig 154 *. . . to about four inches from all the corners.*

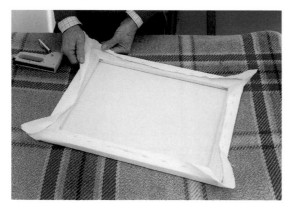

Fig 155 *Pull the canvas corners outwards.*

Fig 156 *Pull the canvas corner over the joint and staple it.*

Fig 157 *Push down three inches of the side . . .*

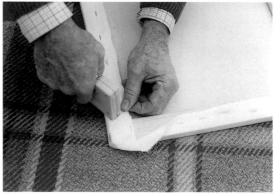

Fig 158 *. . . and pull it up and over the stretcher, stapling it in place.*

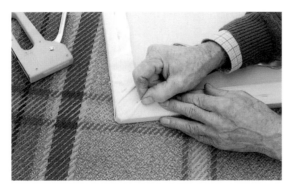

Fig 159 Pull up the other side and staple it with the fold exactly on the mitre line. Note the difference between the two folds.

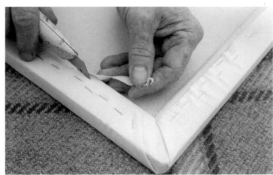

Fig 160 Trim off surplus canvas.

Fig 161 Tap wedges into the prepared slots.

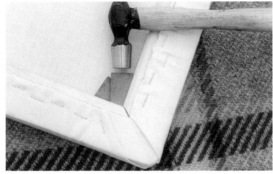

Fig 162 Note the way the wedges are fitted, their right-angled corners outwards.

Push the canvas edge down outside the stretcher, approximately three inches.

Pull the outer edge upwards and staple it to the stretcher.

At the other edge, simply lift and pull the canvas over so that its fold runs up the diagonal joint of the stretchers.

Secure the canvas with more staples (the thinner the canvas, the closer the staples), and trim the canvas edges. Drive in wedges to stretch the canvas. Note carefully the way in which they are inserted. The right angle of the wedge is always outermost. This helps the hammer to open the joint evenly.

Do not overstretch at first, especially when using thin canvas. New canvas can be sprayed with water and allowed to shrink dry before wedging out. Your first efforts may be a little clumsy but you will soon get the hang of it. Old canvases of heavy weave will be a real test of skill, but are often on thick stretchers, which makes it slightly easier.

RESTORING PICTURES ON WOODEN SUPPORTS

The main types of surface cleaning, paint layer restoration, and discoloured varnish

95

removal, are done on boards in the same way as on canvas, but the work is helped by the rigid, steady nature of the support. This makes it easier to be precise in the pressure and solvent treatments you apply. Cracking of the paint itself is marginally less likely to have occurred, and if it is present, some of the methods used on canvases can be adapted. But, as with everything in restoration, there are a new set of problems! These are the various kinds of damage occurring in the board itself, for example splitting, warping, rotting, mould or pest attacks such as woodworm, nails and screws coming out, old bracings coming adrift, plywood becoming separated in layers and so on. Start by checking the exact nature of the support.

Is it some form of plywood? This will be evident on inspection of the edges. A likely defect is when some layers have separated, and are bulging or curling up. The paint layer itself may still be attached and undamaged, but cracking may be evident under magnification. As with curled or folded canvases, paint cracking on the outside of a curve will result in the paint stretching or acquiring opening cracks. These will close up once the curve is removed. More serious is where the paint layer is inside the curve, as this causes crumpling and breakage in the paint film. The levelling process will open out the crushed parts, and they may then fall off. Repairing ply damage can be done by injecting wood adhesives between the separating layers and cramping them together. Warming the wood before bending it may soften the paint slightly and make it less likely to flake off. A more time-consuming and painstaking method is to remove all but the top layer of ply, working from the rear with very sharp chisels, then carefully glueing the painted ply layer with

PVA wood glue to a fresh piece of marine-grade ply. Not a job for the inexperienced.

Is the wood a solid panel, in one piece or several strips joined side by side? If any panel of this type has an old, carefully made supporting framework, it is likely to be a painting of some value, and should not be worked on until it has been checked by an expert. It may have been specially made for the artist, or be a recycled piece of old furniture. Problems here include splits along the grain and general warping. Curving will produce the same problems as plywood, but not so dramatically because the curves will not be as sharp. Splitting is a joinery matter. Indeed, co-operation with a skilled woodworker is almost essential for a restorer dealing with such wooden supports.

Is the wood an artificial board? Modern paintings may be on manufactured block-board (a thick and solid version of plywood), or hardboard (a compressed fibre board, very suitable for paintings if supported by adequate wooden framing). Both of these may warp in poor storage, or indeed in excessive heat, for example if hung over a radiator.

Is the board simply thick card? 'Boards' such as this are common among amateur painters, and simply consist of thick card-board, primed on one side, or a similar card with thin (often very thin) cloth glued on. These are easily damaged by damp, the priming or facing cloth sometimes becoming partly detached. The simplest repair is often to remove the surface entirely, a job that is usually quite easy using a table knife slid between the two, and re-glue it with BEVA to a stronger material. Keep the picture flat at all times to avoid cracking and follow the universal rule – *never* remove a painting from its support; remove the support from the painting.

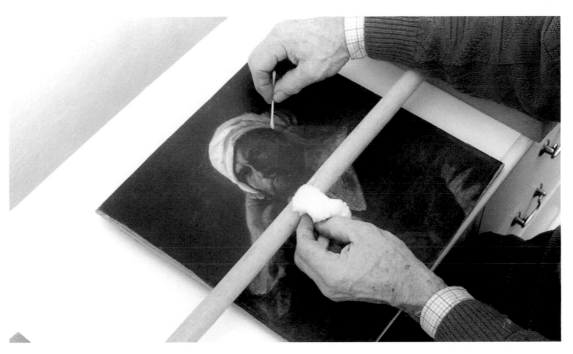

Fig 163 *This old canvas portrait had been laid down previously on board. After cleaning it was decided to remount it on new canvas edges.*

Fig 164 *First, several layers of the support board were prised away.*

Fig 165 *The rest was carefully hand-pared free, using a blunt-edged palette knife.*

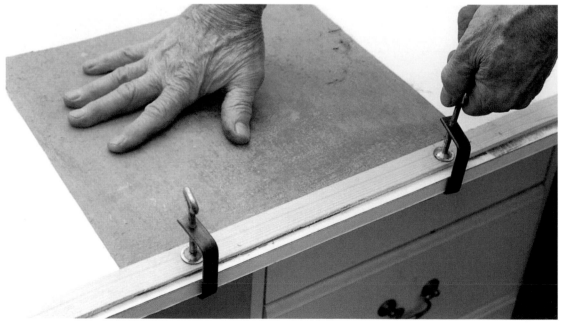

Fig 166 *Once free of the board the canvas was clamped flat on a smooth surface for final scraping. . .*

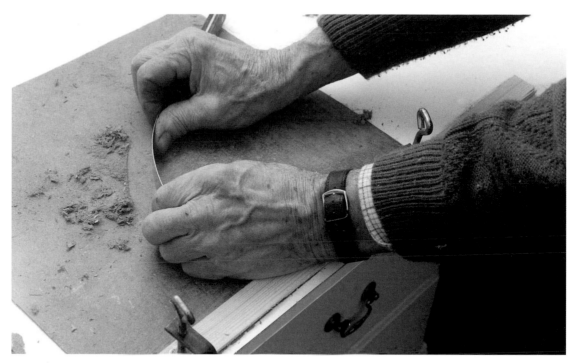

Fig 167 . . . using the flexed palette knife pressed flat.

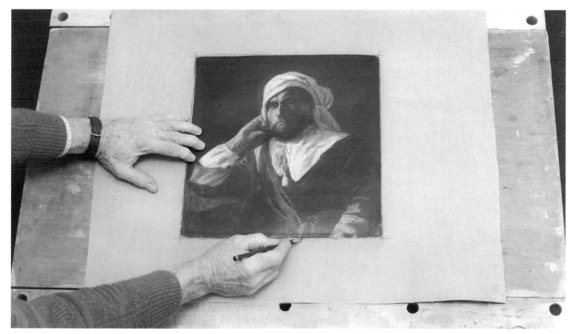

Fig 168 The picture was laid on a new canvas and its outline pencilled in.

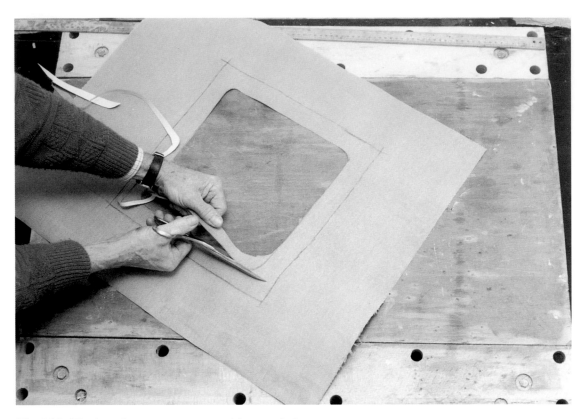

Fig 169 The interior was cut away with rounded corners . . .

Repairs and inpainting on boards are done in the same way as those on canvas. Making filler 'plugs' up to the level of the paint surface can be done with materials a little less permanently flexible. Even some commercially available 'wood fillers' will suffice for paintings of low value. All such fillers must be varnished thinly just before the final colours are laid in place, to prevent possible colour change by reaction with the insert. A simple and cheap material for this is plain egg yolk, the basis for genuine old tempera paint. Crack the egg and separate the yolk sac from the white. Hold the sac above a jug, slit it and squeeze out the yolk. Then add a little plain water and brush it into place. This gives a quick-drying adhesive or medium,

on to which you can apply water-colour straight from the tube, or acrylics, to complete the inpainting (it does not dry yellow).

DEMONSTRATION 7 – SUPPORT-LINING A BOARD-MOUNTED CANVAS

This portrait, mounted on an early form of hardboard, turned out to be very interesting on testing, and possibly valuable. The board was disintegrating and it was decided to transfer the painting to a new canvas, not a lining, but a support canvas attached to its edges, This would leave the original canvas open for treatment from the rear, if it ever became necessary.

Many such boards were made by glueing together layers of pulp card that can

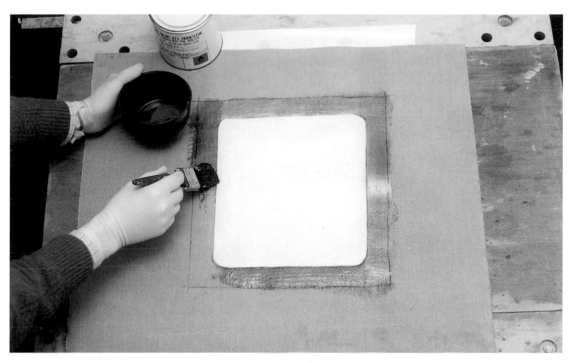

Fig 170 . . . and adhesive applied as far as the outline.

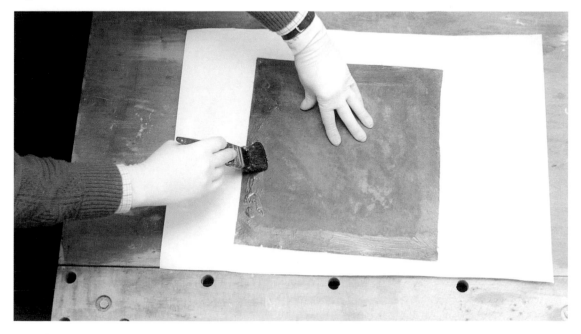

Fig 171 Laid on silicone release paper, the picture rear edges were coated . . .

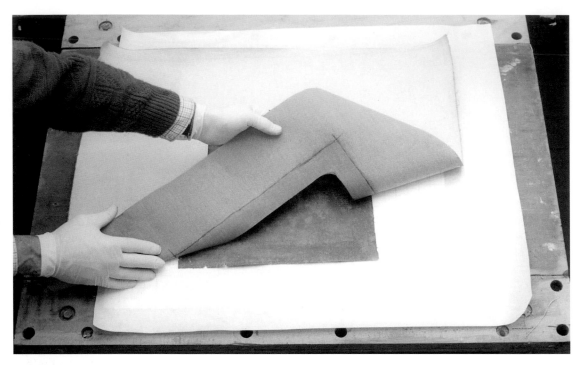

Fig 172 ... and after drying, aligned with its new canvas.

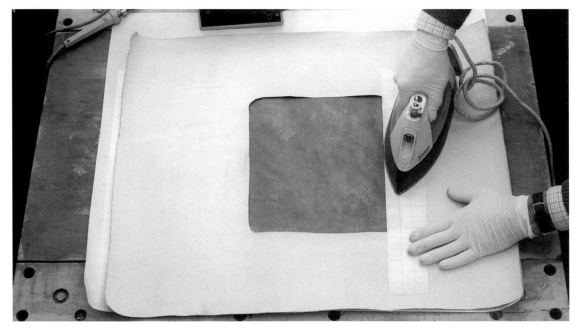

Fig 173 Careful ironing through release paper activates the adhesive.

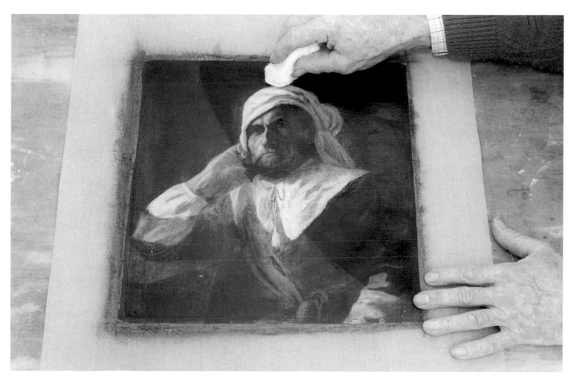

Fig 174 A final light cleaning will restore its colour, ready for re-stretching.

be split free. Note again the universal rule that you *never* remove the picture from the support, always the support from the picture, which should remain flat at all times.

Note also that I use a heavy domestic palette knife, with no sharp edges, to prise the pieces free.

As the rear of the canvas becomes visible, clamp one edge of it securely to the edge of a bench to prevent accidental folding in the last phase.

Flex the palette knife and press it to the crumbling card next to the canvas, working away from the clamps.

With all the old board removed, the painting could be simply adhered to a new board, using BEVA. For a support lining however, take a sheet of canvas and pencil the outline of the picture in its centre.

Cut out the centre of the outline, approximately 36mm (1½in) inwards from the pencil line, rounding all the corners.

Working over a sheet of silicone release paper, apply adhesive inside the pencil outline and allow it to dry.

Then apply adhesive to the outer 50mm (2in) of the painting.

Carefully matching the picture outline with the pencil lines on the support canvas, lay them together.

Iron the adhesive strips to bond the two together. If it were a larger canvas I would secure and stretch it firmly to the bench, making it easier to keep it flat to the rear of the painting.

Finally, the picture should be fully cleaned, re-varnished and attached to new stretchers.

WATER-COLOUR PAINTINGS

Water-colour paints are created using pigment powders, the same as oils, but are held in place by a weak, water-soluble glue such as gum arabic. There are other possible constituents, particularly in older paintings, but gum arabic is the main one. In any case, the actual medium need not be precisely known in order to make satisfactory restorations. Water is used to dilute the paint to create any intensity, from practically neat pigment to almost invisible washes.

Commercially prepared colours may be in a solid cake form, which are easily moistened to bring off colour by the action of a brush. The pigment content in this form is high. Alternatively, collapsible tubes contain a similar paint but with more diluent, giving a consistency that is barely stiff enough to retain its shape when squeezed out on a palette. Incidentally, if a tube is accidentally allowed to dry out, the remaining hard paint can still be used as if it were in a pan.

The colours are usually applied with soft brushes, the best being made from the tip of the centre tail hairs of the Kolinski sable from Siberia, but other hairs and new artificial fibres are now available. Many artists also use sponges and other textured implements to make particular marks.

METHODS OF WATER-COLOUR PAINTING

CLEAR WASH AND WET-IN-WET METHODS

Many artists first evenly coat the whole support paper with plain water to reduce its absorbency and help the flow of paint. This is allowed to soak in until the 'glitter' of it vanishes. This water fills the pores of the paper and helps to distribute the applied paint, laid on immediately afterwards with large brushes, in soft, evenly graded washes of great delicacy. If drops and swathes of paint are laid into the still-wet water and paint, complex, spontaneous colour groups and shapes can arise, a technique known as wet-on-

Fig 175 A typical English-style water-colour of a sailing barge and tug.

wet. Once dry, such water-colour washes will withstand further repeated washes being added one over the other to build up complex colour effects and patterns. This multi-wash technique was widely used in Victorian times.

SHAPED SURFACES AND SPACED WASHES

In this method, little or no pre-wetting of the paper is done and the work is drawn directly with the brush, in shaped areas that are generally fairly small. The patches of colour may touch or slightly overlap to give a continuous layer of pigment, or they may be left slightly apart, with narrow white traces of plain paper exposed between them, giving a very distinctive appearance that should be continued in any detailed inpainting.

PENCIL AND COLOUR

Yet another traditional school of water-colour painting involves making a light pencil drawing of the main outlines of the picture on the paper support and adding controlled patches of wash within these outlines. The pencil lines may eventually be erased, but are often deliberately left in place by the artist, especially in recent times. When restoring this style of painting, visible pencil lines must not be removed. They are sometimes added to areas being inpainted, but this is considered unethical and should never be done on any picture of significance or value.

DRY PAPER, DRY BRUSH AND SCULPTURED WORK

In these methods the paper surface is either used dry and rough, without pre-wetting, or is allowed to dry out completely after washes

have been laid. Very light brushstrokes will then produce a texture as the upper peaks and irregularities of the paper drag off colour, the 'valleys' between being left white or with the dried wash alone. The effect is most marked if the paint applied is itself fairly dry. A few economical strokes can then achieve many evocative effects, with highly complex patterns and textures, especially suited to landscape features such as rocks and foliage.

A related effect is achieved by sandpapering and scraping fully dried washes to remove paint from the raised parts of the texture, leaving them white.

Finally, small, flat, stiff-bristled brushes may be dampened and methodically scrubbed over washes, removing controlled amounts to produce many carefully constructed effects, often with a sculptural quality.

White pigments are not normally used in these 'transparent' water-colour methods, either for white marks or the lightening of colours. Instead, the paint is made more transparent using water. Full whites are produced by leaving the support paper unpainted.

INK AND WASH

Black carbon ink may be combined with pencil or plain washes, particularly to produce highly contrasted, sharp-edged images. The ink may be applied with pen or brush, sometimes under the wash, as a guiding drawing, but is often applied over the wash to intensify the image. Such pictures are treated as water-colours for restoration work.

WATER-COLOUR PENCILS

These are essentially water-soluble paints, similar to those in pans, arranged in wooden pencils so that they can be moistened

and applied without brushes. Water applied on top of the pencil marks spreads the pigment in a wash-like manner around the original lines. Their main use is as convenient portable paints for outdoor sketching, and for restoration they are treated as ordinary water-colours. Some are fugitive and fade rapidly in sunlight, and the bleaching process may damage these.

BODY COLOUR OR HEIGHTENING

Although white paint is not generally used in transparent water-colours, any white parts being indicated by plain paper, in many instances painters have added small marks of Chinese white (zinc white) to add sparkle or to make a white mark on a deeper coloured background. This is known as 'body colour' or 'heightening'. Under magnification, these marks are easily seen to be different from their surroundings, while during restoration by immersion methods, such thick paint occasionally dissolves away.

SOLID WATER-COLOUR

Sometimes, especially in amateur paintings, pale sky colours may be produced by thinning with water, while the main areas are painted with solid patches of water-colours taken straight from the tube. This paint lies on the surface like heightening and presents similar problems to the restorer.

GOUACHE OPAQUE WATER PAINTS

A water-colour paint that is not translucent, but rests on the support as an opaque layer, has to be rendered solid by mixing it with chalk. Such paint is usually called 'gouache' or sometimes 'designer colour' because of its widespread use in

Fig 176 Water-colour in heavy water-colour, virtually gouache in character.

the graphics industry. The paint, supplied in tubes, has a creamy consistency and produces a smooth, unbroken surface that is ideal for illustrative camera reproduction work. Like transparent water-colour it is applied with soft brushes but is not thinned out into washes, and even large, pale areas are covered with undiluted paint. Being opaque, all the colours can be laid over each other without difficulty, in particular, light colours over dark. The detail potential for gouache is great; it has a smooth, sometimes even eggshell look that can be confused with acrylic. However, dry gouache is soluble in water, while acrylic is not. Restoration problems are as for body colour, the paint tending to lift off if immersed.

MIXED METHODS

Combinations of wash, wet-in-wet, dry brush, pencilled, body colour and gouache are common and the permutations in appearance endless. The damage they all sustain and the general restoration methods used are largely similar, but call upon the experience of the restorer a great deal. Generally speaking, modern

work will often be more fragile than older pictures.

SURFACE FINISHINGS OF WATER-BASED PAINTINGS

Once dried, water-colours require no fixative or varnish. However, occasionally water-colour paintings have been glazed with varnish to intensify colours and give an effect, when framed, rather like smooth oil paintings. These pictures, if done smoothly on rigid card, can be very difficult to identify as water-colour at all, and are tricky to restore if the varnish becomes darkened with age without causing an unpleasant, patchy effect.

HOW WATER-COLOUR PAINTINGS DETERIORATE WITH TIME

Some of the most ancient paintings in the world are in water-colour, and in spite of their seeming delicacy they can be extremely tough. Their weaknesses are of three kinds.

(1) Problems with their supports (usually paper), which can suffer from dirt, fungus attack and increasing fragility due to chemical changes. Silk is widely used in the Far East and has the same weaknesses, plus a greater susceptibility to insect attack.

Most water-colours gradually become dirty, for their old frames will usually have lost their protective backing paper providing access for all manner of dust. Many will have spent long periods unframed and so have been subject to even greater risks in casual storage. Surface dirt is therefore an obvious hazard and can take many forms, the simplest being dust and household dirt. Sticky marks such as the remains of adhesive tape, food stains (yes, it does happen), candle wax, spots of paste or glue used in framing may have become embedded in the paper surface. Greasy or oily marks may also have entered the paper texture, even soaking completely through.

Fungal attack, encouraged by damp and poor ventilation, can rapidly produce green-black mould that spreads over the paper surface, which in turn becomes increasingly fragile. Foxing is a specific form of mould attack; it is a complex process, common but not entirely understood, in which the paper becomes infested with gradually darkening brown spots, often creeping in from the edges. It is known to be associated with damp and fungal attack, but is also related to chemical changes in the paper itself. The initially pale creamy brown spots gradually get bigger and darker and ultimately turn completely black in their centres. When this stage is reached it is only a matter of time before the inner part disintegrates into a black-edged hole.

Increasing acidity is a recurring problem because all paper has a tendency to become gradually more acidic with age. This makes it progressively fragile and is indicated by its changing colour from yellow to brown, often from the edges inwards. You can see a common example of this in old newspapers that have turned brown and which fall easily to pieces when handled. Paintings are usually made on rather better quality paper than this (although not always in modern times!), so may not become weakened as quickly but the risk is always there. Putting together shattered paper bits is one of the most time-consuming and aggravating jobs a restorer can undertake.

(2) Changes in pigment colour are widespread, usually through the action of light. Stored untouched in dark, dry conditions as in Middle-Eastern tombs, they can survive unchanged almost indefinitely, but

soon weaken if removed. Many Chinese and Japanese paintings have survived for centuries because they are not displayed on walls but stored rolled up, and are only unrolled occasionally to be viewed traditionally by candle light.

Colour changes or fading in water-colours are in theory no more likely than in other mediums because the pigments used are fundamentally the same. In practice however, water-colour paintings do fade more, perhaps because the individual grains of paint are not sealed in as tightly by the medium as they are in oils. Also, the paint layer is so thin and the individual particles so scattered, that they may be more completely exposed to changes caused by strong light.

Another factor is that many water-colours were and are produced by artists using cheap materials that are not entirely stable. When looking for colour fading, you may be able to check parts that have been concealed under the edge of the mount or frame. These areas are often a strikingly stronger colour, untouched by light and less affected by damp.

(3) Abrasion, cracking and dusting as the medium deteriorates. Heightening, body colour or gouache that rest on the paper surface in solid opaque layers are especially susceptible to these problems.

Physical damage to elderly water-colours is common, and most have suffered some form of tearing or abrasion. Atmospheric moisture may have produced irregular swelling so that the paper will not lie flat; thick papers may even separate into several layers. Any repairs made in the past may themselves now present problems, for unsuitable materials were often used.

HOW WATER-COLOUR PAINTINGS ARE RESTORED

As always in restoration, the first job is to test your picture, finding out how it was made, the nature of its support, and any obvious defects. When making any tests, try to avoid touching the surface with bare fingers as nearly all skin is slightly greasy; wear clean cotton gloves. The main risk, however, is actually touching any wetted picture surface. Body colour brushstrokes can vanish instantly as the pigment breaks up under pressure from a wet finger, while even underlying wash colour, deep in the paper texture, can shift, resulting in clearly visible defects in a previously even finish.

Start from the basis that all paper works are fragile and likely to be damaged if handled roughly. Treat any picture with caution, supporting it on a rigid base of clear plastic or board, especially if it shows any signs of tearing or discolouration. It is good practice to slip the picture and its backing into a transparent polythene envelope for study.

Now check it carefully, using a

Fig 177 Mild foxing and discolouration are visible under magnification.

magnifier, observing the items listed below.

● The Paint Layer

The 30x hand microscope may be useful for this purpose. The background and most of the foreground of a water-colour, except perhaps for a few, sharp details, may be relatively smooth, with the paper texture clearly visible. This indicates the transparent work method, with thin colours soaking in to some extent and little remaining on the surface. Other pictures will have much thicker and more heavily applied paint areas, some even with thick, visible brush marks. Under magnification it is easy to see that these are resting on the paper surface. Where the paint is scattered and white only, it is heightening, and the pigment is Chinese white. Where the paint is coloured, it may be simply ordinary water-colour taken straight from tubes and applied with very little water, or it may be an actual opaque gouache paint or commercially made tempera.

● Dirt and Other Surface Discolourations

These may be of five kinds.

(1) Material particles stuck to or resting on the surface; actual dirt, as you might say. These appear as raised lumps or groups of particles, depending on the degree of magnification, and may be household dust or insect droppings. A gentle touch with a soft paint brush may be enough to disturb them.

(2) Non-paint stains which have soaked partly into the paper, for example grease spots and drink spillages. These have a smoother, perhaps a slightly glossy or oily appearance and their outlines are usually sharp.

(3) The brownish spots of foxing. These affect the paper irregularly, though are often more numerous near the edges. They show a wide variation in colour, the darker ones being the oldest. In general the outer edge of each spot is light, gradually becoming darker, even black, in the centre, which may ultimately become an actual hole, crumbly edged, blackened and discoloured all round. Such foxing holes indicate an advanced attack needing urgent treatment.

(4) Pencil, pen or paint marks. As discussed, many water-colour artists make pencil outlines before applying colours and often deliberately leave them in place after completion. Others use ink lines and brush marks as part of the picture. Such marks are not usually defects and are never removed.

Note that any writing on the face, rear or framing of a picture should only be removed after careful thought. Signatures are often added after completion by the artist in pencil or ink, however even if they are additions by a dealer, museum or framer, they may help with identification and dating. Always photograph or otherwise record what is there, particularly if you decide to remove it.

(5) Physical damage. Paper is very likely to be torn, scraped or pierced at some time. However, tears and holes can usually be repaired and the work, though intricate and time-consuming, can be successful with a little practice.

All these factors affect the choice of treatments and it will take time and experience to learn to distinguish between them. A good way of learning to recognize the differences is to deliberately paint on, dirty up and stain pieces of new and old water-colour paper with various substances and study the results.

It is harder to make invisible repairs to traditional, transparent water-colours than to surface paintings such as gouache, oils or acrylics. The very thin watery paint, coupled with moistened support paper, means that the pigment coverage may be very slight indeed, a mere hint of colour, with the background paper showing through. The paint frequently soaks in well, sometimes right through the paper. Repairs can then be very difficult to complete without some visible surface change, especially in light areas such as skies.

It is advisable to use a different medium to that of the painting itself for inpainting, so that repairs can be easily distinguished. However, gouache that lies on the paper surface, oils that penetrate the paper and are heavily textured, or acrylic with its eggshell finish, are all very difficult to use in an unobtrusive manner. Apart from using water-colour itself in tones of grey, which would then be identifiable as re-touching but might be obtrusive in appearance, the best method of inpainting water-colours is in fact to use pastel, which is surprisingly easy to blend in with water-colours by rubbing into the paper texture.

The main problems are the removal of surface stains or dirt, clearing fungus attacks such as foxing, and repairing physical damage to the support.

Before tackling a genuine water-colour, try the work on a coloured print rather than an original. You can work through all the procedures step-by-step, which will provide you with good training in one real problem area, handling wet paper, without the risk of damaging an original water-colour favourite. Then move on to low-value genuine water-colours.

DRY CLEANING

Removing Surface Dirt
Where surface dirt is the main or only problem, dry repairs are much safer than any form of wetting, especially for new-comers to water-colour restoration, and are frequently successful. You can apply gentle treatment with paper-cleaning granules, available from office suppliers. Note though that the process is a rolling rather than a rubbing action.

I have had excellent results with the simple and traditional use of ordinary, clean bread crumbs spread dry on the picture surface

By rolling the bread crumbs gently over the surface of the picture they visibly take up surface dirt. This can make a surprising difference to a slightly grimy painting. Either process will often transform the clarity and sparkle of a dulled image.

Another method is to use putty rubber, a tacky material supplied by art suppliers. Again, do not use a rubbing action. Instead, mould small pieces of the rubber into cylinders and roll them over the surface. Never use large pieces of bread or solid blocks of pencil or ink erasers to scuff at any paper surface.

Fig 178 Clean bread, crumbled in the fingers, makes a safe paper cleaner.

Fig 179 Roll the crumbs lightly over the sur-face. They will darken with picked-up dirt.

Fig 180 Sparse foxing surface dirt can be removed with a scalpel.

Unfortunately, these 'dry' methods, often safe on transparent water-colours, may sometimes damage and remove heavier surface pigments, especially Chinese white body colour or colours applied straight from tubes. The risk increases with the age of the picture. Any colour traces appearing on the cleaning crumbs are warnings that pigment is being lost. Such weakness is also an indication that the picture is going to be difficult to clean, however it is approached. In professional work, if the picture was of significant value, I would suspend all operations until I had consulted with and warned the owner.

Dirt and Foxing Reduction

The dry treatment of foxing on water-colours (or prints) can be done, and is safer for newcomers than immersion. The process is essentially very simple.

The discoloured spots are gently scraped away with the tip of a new, sharp scalpel. For this you need clear vision, a magnifier on a stand and a steady hand, but with practice a quick and effective result can be achieved.

Arrange the picture on a flat surface and slip on your cotton gloves. Scrape gen-

tly inwards from the edges of each spot with the scalpel held almost vertically. At the centre of larger spots you will have to scrape a little deeper. The foxing marks will still be faintly visible as rough little pits in the paper surface. Actual dirt flecks, insect droppings and so on can also be removed by this process.

Turn the picture over and place it on a piece of strong glass. Drip clean water drops on the rear of the foxing pits. Let it soak for a few moments. The paper may darken, but this effect will disappear when the paper dries. With a small chromium or stainless steel teaspoon (not silver), press down behind each spot, squeezing the moist paper up against the smooth glass. When it dries the paper will be smooth and clean.

If the middle of a large foxing spot is black, this may go right through the paper, so your scalpel may make a tiny hole. To fill this, mix a creamy pulp from a piece of spare paper cut from the edge of the picture, squashed and ground up in a trace of paper adhesive. Apply *tiny* drops of this pulp behind each hole, pressing them smooth and level with the spoon, and checking the effect through the glass as you go. Leave the picture pressed on the glass to dry.

111

The general effect will usually be quite good, though it will not actually kill the foxing, which is a complex fungus effect and may recur.

FUNGICIDE AND BLEACH TREATMENTS

Liquid bleach or fungicide can be sprayed from the rear of the picture, if the whole picture is to be covered. Certain pictures such as this silk-mounted Japanese-style painting, however, can only be given wet treatments safely if the chemical is localized.

Using an arm rest, apply a specialized bleach such as Chloramine T with the tip of a fine brush. Before touching the surface, tap the brush tip with your finger to dislodge any large drops. Several applications may be needed. If spots go right through the support it is best to work from the rear, but in this case the work was backed in card and silk.

IMMERSION TREATMENTS

Dirt and Foxing Reduction

Dry cleaning is not always completely effective if the dirt is engrained or sticky. Old adhesive tape, for example, leaves glue

Fig 181 When working on fragile items, a 'bridge' arm rest prevents contact with the work.

Fig 182 Pictures not suitable for immersion can have weak bleach applied to foxing with a fine brush.

traces and strongly attached dirt that may be partly removed but will leave deep stains. Fortunately, although it looks fine and delicate, even transparent water-colour paint is not inherently fragile, nor does it easily wash out (as any artist trying to remove a mistake knows well!). When immersed in water or other solutions, some pigment particles may be loosened, but they cannot easily escape the fibres of the paper and will often re-attach themselves as this dries.

Consequently, you are not likely to lose much paint permanently, although some blending of adjacent colours may occur. This is not to say that you can push ahead regardless. If you finger the surface of wet water-colour you will certainly detach some paint, but if you take care in handling, the risk is much reduced.

First, test just how fragile your picture is in water. To check the strength of the paint, prepare a suitable tray, half full of clean fresh water at just higher than room temperature, barely warm to the touch but not hot. Stir in detergent at about three drops per litre. Place the picture face up on a piece of carrier glass and slide about 25mm (1in) of its end into the liquid. The

paper will suddenly darken or discolour, however this is not a problem. Keep the water swirling gently but watch the paint for any sign of movement of the pigment. After thirty seconds, remove it from the water and lay it flat to dry; do not dab at the surface to dry it, simply leave the picture to dry naturally in a warm place with a steady flow of fresh air. If you see any signs of pigment floating before that time, take the picture out at once. This will show that immersion may be too risky.

On drying, the paper may seem to be absolutely unchanged, though it may have warped a little. The wetted area may not even be detectable. Such a result shows that the pigment is at least reasonably bonded in place and will not dissolve and float free, as certain very cheap water-colours may.

On a fairly dirty picture the extreme edge of your wetted patch may show a faint dark line where the dirt has been washed together. Again, this is satisfactory and can be washed away later. However, if the line is coloured rather than dark, beware! This means the paint itself has partly dissolved and you may need to use dry methods only.

If the test is satisfactory, you can now take a bold step and totally immerse the painting, gliding it under the water in one smooth, continuous motion. It is important to wet the whole surface and if need be you can tilt the water tray once or twice until the picture gently sinks. However, total immersion must never be accompanied by any sort of vigorous movement or rubbing. The most that can be allowed is a very smooth, slow and gentle rocking, just enough to circulate the liquid and dissolve the dirt. Fast-moving water can scour a soft or powdery paint surface. As always, avoid touching any wetted area with your fingers, no matter how gently. Any contact may disturb or pick up traces of pigment,

leaving a smear that may take a long time to disguise.

To avoid the risks of full immersion to really delicate paints, you may use localized wetting instead. Liquid is not applied by brushstroking in the normal way, but is dripped or dribbled into place from the extreme tip of a soft brush held just above or laid gently against the paper surface, or from a strip of blotting paper laid on without rubbing. Safer still is to paint the liquid on with a normal brush action from the rear of the paper support.

Heightenings in white or heavy paint are more likely to partly dissolve or even break free in flakes if immersed. In fact, you may occasionally see the process happening, as the spots of Chinese white give off little plumes of pigment that drift from the brush marks when the paper is shifted about. If allowed to settle, these particles may re-attach themselves as a visible, faint white mist nearby, showing up particularly on dark brushstrokes. Again, this result is not always a complete disaster, since there is usually a reserve of underlying paint, but sometimes a large number of paint flakes may be shifted or lost. On a few occasions I have seen sudden, unexpected disintegration of brush marks, perhaps because they had not dried as a solid, but were hollow. Since such events are unpredictable, they emphasize the need for working slowly, cautiously and with close observation.

Bleaching
Bleaches for cleaning water-colours are always weak, for example sodium hypochlorite or Chloramine T, and must be freshly prepared every time. The actual process is identical to your trial cleaning of a print (*see* Chapter 5), bleaching and washing, keeping the work under observation, checking that foxing, if present, seems to be dimming, and so on. Com-

plete drying after partial cleaning is desirable, even if further bleaching later proves necessary, because only by such checking can irreparable overbleaching be avoided.

Once the bleaching is finished, use at least two changes of wash water immersion to remove traces of chemicals. I have never known serious problems with Chloramine T being left unwashed, but it is definitely good practice to rinse thoroughly any paper work after even mild bleaching. If you are confident that the paint itself is not dissolving away, a continuous, very gentle flow with a tap feed will remove almost every trace of bleach.

Immersion will remove the sizing from many papers and retouching paint will spread unpleasantly on unsized paper. Dipping paper in a weak gelatine solution, half an ounce to one gallon, will usually be adequate to correct this so that any necessary re-touching work can then be done. Many restorers apply a fungicide such as Thymol in the last wash to preserve the paper in future, but some research has indicated that this may result in yellowing. In any case, the best fungal protection is perfectly dry framing and hanging.

REMOVING OIL AND GREASE STAINS

This is a complex matter, for the simple reason that there are thousands of different substances that can stain a picture. Also, you obviously cannot use a stain remover that will attack the picture itself. It would be quite possible to devote an entire book to the myriad possibilities, but fortunately most such marks are automatically removed by the restoration procedures described within this one.

If the mark is on the picture surface, as opposed to soaked in, always start by removing as much of it as possible manually by scraping and shaving, before applying any solvent. All too often, smearing solvent over a mark will spread it about.

After this, most oily stains can be removed by solvents such as white spirit, methylated spirit or acetone (do not use acetone on acrylics). You can also use dry cleaning fluid such as carbon tetrachloride or petrol; use these outside the house, firstly because of the fumes and secondly because you should never use petrol in the house as even the pilot light from a gas appliance can cause an explosion.

Non-oily stains can often be removed with stronger bleach than is used for general paper cleaning, provided it is applied directly with a fine brush and you realize that you may have to inpaint a pale mark afterwards.

Adhesive stains and spots can drive a restorer mad, after all, they are designed to hold tightly. The best general advice I can give is to contact a supplier of similar adhesives and explain the problem. I have found the technical departments of even major companies very helpful if you ask politely, preferably by letter (direct the initial enquiry to their public relations manager, if they have one).

Some marks simply cannot be removed, and you will either have to accept them as evidence of age, cut them out complete with their supports and reinstate them, or conceal them by painting over with acrylic. As a consolation, I can say that in many years I have rarely had a problem with a stain or mark that could not be dealt with using basic restoration methods and materials.

REPAIRING HOLES AND TEARS

Paper is easily damaged, and a large part of a restorer's work is dealing with tears. If the picture is a high-quality water-colour there is a good chance of success, because the

paper will almost certainly be made from fine rag, is likely to be quite heavy and will have been framed properly from the start. It can often be re-joined by paste at the torn edge. Cheap prints and oddments of illustrations from books or magazines may on the other hand be practically irreparable, at least at a reasonable cost, because they will probably be too weak on their own and may need re-mounting on a new, strong support paper.

For straightforward tears at the paper edge, which will usually be hidden behind the mount (known as 'mat' in the USA), high-quality acid-free adhesive tapes prepared to conservation standards will give good service. Simply match the torn edges under the tape, and apply pressure to secure it. Ultra-thin tape is practically transparent and can be applied to both sides to make a stronger job. Personally I use such tapes where practicable, because they prevent further damage, are easily removed when necessary, and cost very little in materials or time.

DEMONSTRATION 8 – REPAIRING A TORN PAPER WATER-COLOUR OR PRINT

When a fresh tear is visible on the picture surface, the paper will probably have 'feathered', ripped apart with a bevelled tear, so re-alignment should be fairly easy.

Place the print face-down on glass or your plastic work shield, with the edges of the bevelled tear carefully aligned.

Apply conservation tape to hold the untorn print edges to the glass to prevent slipping.

Look through the glass to check that the tear is closed, adjusting it as necessary.

Apply tape along the tear, checking that the split does not open, then press the tape firmly down to seal it. More than one tape layer may be applied without undue bulking.

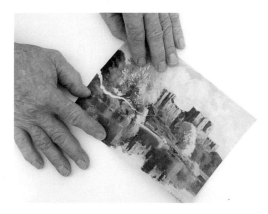

Fig 183 Newly-torn pictures often produce 'feather edges' that are relatively easy to repair.

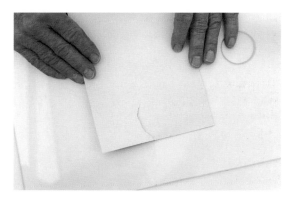

Fig 184 Using conservation grade adhesive tape, fasten the picture edges face down flat on a piece of clear plastic to prevent slipping.

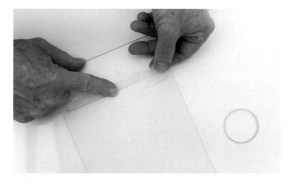

Fig 185 Lightly tape together the rear of the tear with conservation tape.

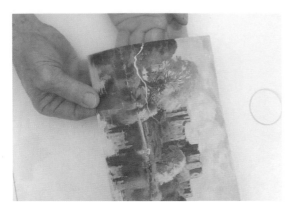

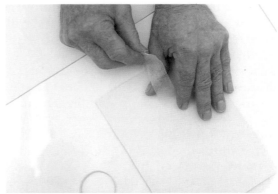

Fig 186 Now when you lift the picture, the tear will spring apart slightly and you can finally check the alignment.

Fig 187 Tape finally the rear of the tear, using several layers.

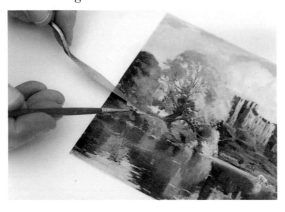

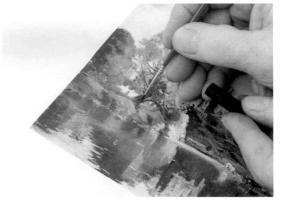

Fig 188 Slight flexing opens the front of the tear and you can apply paste with a fine brush.

Fig 189 When dry, any white paper visible can be dusted over with matching pastel powder.

The bevelled flap can now be glued down. Lift its edge with a metal knife and apply conservation adhesive with a brush to the torn paper, then press together. The faint joint line may remain just visible.

The white paper edges can be finally coloured with matching, dark pastel on a fine brush. The result is a practically invisible repair.

The best results are achieved with freshly-made tears. Old damage is more difficult to deal with. The fibres torn apart will have lost their alignment and may be fuzzed up or missing. The edges may even have become soiled or some paper completely lost. Repair in this case can be approached in a similar way to that of a fresh tear, but in addition you can make up paper pulp as a filler to replace the missing areas. There will usually be an inch or two of surplus paper around the picture edges where few small pieces will not be missed. Soak them in adhesive paste thinned down with water and then pulverize them into a fibrous pulp.

With the paper secured as above, face-down on glass, tease the torn paper fibres

inwards from both sides of the tear, inter-weaving them if possible. Then work your filler between them to close the gap, using a fine spatula and soft brush. You can see whether the pulp is spreading satisfactori-ly by lifting the glass. Once aligned, remove any surplus pulp and smooth the rear, allowing it to dry without heat. Small holes are filled in the same way.

DEMONSTRATION 9 – REPLACING MISSING PAPER IN WATER-COLOURS OR PRINTS

Large holes, where the original area has been lost, must be patched with fresh paper of similar thickness. It pays to obtain a paper that matches the original exactly in colour, perhaps from its own margins. Papers differ in their shrinkage and other reactions, and a patch from an unsuitable paper may cause warping or come adrift. Cut away any white original paper showing at the hole edges, nearly up to the colour.

Using a fine wet-and-dry abrasive paper wrapped around a brush handle, sand away the rear of the hole in a shallow bevel, all the way round. This bevel must go right up to the colour.

Pencil lightly all round the bevelled hole on to your patch paper.

Fig 190 When complete and framed. Such a repair will be practically invisible.

Fig 191 Rather more tricky are actual holes with missing paper.

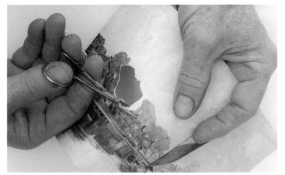

Fig 192 As usual the paper may have feather edges. Cut away any white paper seen from the front of the picture.

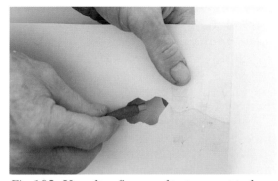

Fig 193 Use ultra-fine sandpaper wrapped round a brush handle to bevel the rear of the hole.

117

Fig 194 Slip repair paper under the hole and mark the outline with pencil.

Fig 195 Cut the paper patch 6mm (¼in) larger than the mark.

Fig 196 Bevel the patch till the pencil outline just disappears and it fits the hole exactly.

Fig 197 Adjust the size and fix the patch in place with conservation grade adhesive, reinforcing the rear with tape if necessary.

Cut the patch well clear of the pencil mark.

Bevel the upper face of the patch back almost to the pencil mark.

Adjust the bevel until the patch sits in its hole, flush with the surface. Apply adhesive all round the patch and hole. Press the patch into place.

After complete drying, preferably under pressure, the patch can be inpainted. Acrylic or water-colour may be used, dependent on the surface effect required (water-colour is matt, acrylic faintly glossy).

Skill is necessary to work out what the missing area probably showed, but your client will hopefully prefer the finished effect to a blank hole.

Your first attempts at hole repairs may be irregular in thickness and rather weak. If so, the back can be reinforced with conservation grade tapes, though this can look amateurish and you should try to attain the skills necessary to avoid it. Make two dozen holes in some thick old paper and repair them all – that is the way to learn!

Never, under any circumstances, use ordinary office or domestic adhesive tape for paper repair or for mounting pictures.

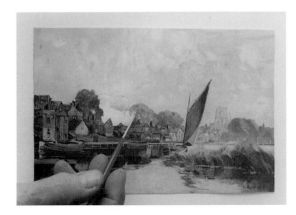

Fig 198 Inpaint the missing colours with acrylic or water colour.

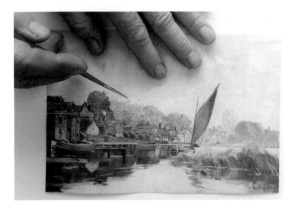

Fig 199 Repairs like this depend for their success on careful colour matching.

Not only do they tend to loosen with age, but, more importantly, they severely discolour paper, making marks that are difficult to remove, and are a sure sign of poor-quality framing or repair.

TREATING LARGE PRINTS

DEMONSTRATION 10 – IMMERSING LARGE PICTURES ON PAPER
Certain water-colours and paper prints are very large; this Capel Hemy print is nearly a metre long. To buy a dish large enough to hold such a piece would be expensive,

and it would be rarely used. You can make a large, simple immersion dish cheaply using basic woodwork skill.

Nail together a frame of 75mm x 12mm timber (3in x ½in), to fit over a sheet of 12mm (½in) plywood of the size required.

Nail the base securely to the frame. Buy a sheet of transparent plastic as a picture support, 200mm (8in) smaller than the frame.

Buy a small waterproof camping sheet and spread it over the tray.

Place the plastic support in the tray and fill the tray with the required liquid. The weight of it will press the cover down and into place.

To remove the liquid, fill a short length of garden hose with water. Place one end under the liquid, lower the other to a catchment bowl, and most of the liquid will siphon out.

FUTURE STUDIES IN PAPER RESTORATION

The technical background of paper conservation is huge and is the subject of many specialist books. Following my suggestions is a reasonably safe introduction

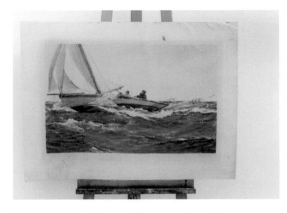

Fig 200 Very large prints can be tricky to immerse for cleaning.

Fig 201 Make a wooden frame large enough for your work.

Fig 202 Nail it securely to a plywood base.

Fig 203 Spread waterproof plastic over the frame.

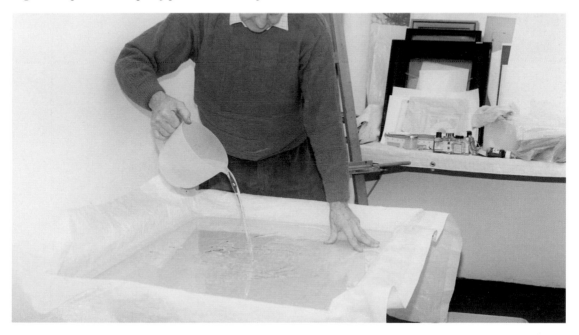

Fig 204 Pour in water, which will push the sheet flat and make a watertight tray.

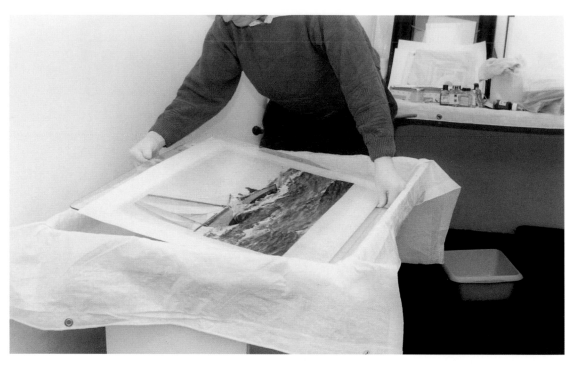

Fig 205 You will need a large sheet of thick plastic to support the picture. It need not be transparent.

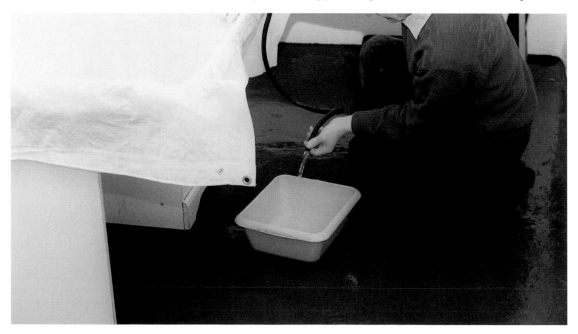

Fig 206 The water and bleaches can be siphoned out as required.

to this fascinating work, but be prepared to extend your studies as you become more experienced. Technical developments occur every year, because a great deal of conservation of irreplaceable books and documents is increasingly necessary. Completely new methods arise, with better knowledge of the immensely complex matter of paper deterioration.

Refrain from working on valuable paper pictures until you can handle the less important ones with confidence. In particular, get plenty of practice in the purely practical matter of handling wet paper; it is fiendishly fragile and can rip in half in a second. I have known more disasters happen through clumsiness in handling a wet print than through any technical errors.

— 9 —

POLYMER (ACRYLIC) PAINTINGS

Acrylics, as the most common polymer paints are known, are versatile, permanent and widely used by restorers for inpainting. They are supplied ready-prepared in tubes or jars, in the usual range of artists' pigments (one or two oil paint pigments do not work well in acrylic, and the only white acrylic is titanium white, but otherwise the colours are identical). The medium is a milky-looking liquid that dries totally transparent very quickly, especially in warm conditions; its diluent is water. The general appearance of acrylic colour is intense, perhaps because of the clarity of the medium. This has led to the widespread but inaccurate belief that acrylics are somehow different from oil pigments. However, it would be more accurate to say that acrylics bring out the natural intensity of pigments better than linseed oil. They adhere strongly to any normal support, such as paper, wood or canvas, and no sizing is needed.

Acrylics can be applied well diluted on to paper, in which case they have a similar appearance to that of water-colours; straight from the tube like oils; or mixed with thickening pastes to produce a heavy, dense and textured impasto in one application. The material is very hard on brushes, its rapid drying causing the paint to harden at the base of the brush, thus spreading the bristles and breaking up the brush point.

Paint in store should be refrigerated to reduce the curing action. Once paint is out of the tube it quickly dries to an unusable state, however there are special palettes that preserve paints while working, using a semi-permeable membrane resting on moist paper to prevent hardening.

The layers of acrylic bond securely one over the other to form a tough, leathery impasto. Indeed, thickly applied acrylic can often be peeled away in a continuous sheet from a smooth support. Acrylics can be brushed out by any normal means, but there are limits to the degree to which they can imitate oils. Classic oil painting involved extensive blending and working of wet paint strokes, sometimes over several days, enabling very subtle gradations of colour to be achieved. Thin glazes can also add delicate subtleties. Neither of these methods are really practicable with acrylics, however, due to the drying speed; an artist in acrylics must work confidently and quickly, as the paint will take its first set within the hour.

Acrylics are relatively inert, leathery and eggshell-surfaced once set. Varnishing is not technically necessary, but plain gloss medium can be used if desired. However, such acrylic varnish has a distinct, rather 'plastic' look and is completely impossible to remove. Pictures can be given a richer gloss and a more traditional appearance by applying an oil varnish such as Damar. The painting cannot then be distinguished from oils by the naked eye. The varnish will eventually discolour to brown in the same way as it does on oils. Consequently acrylics

are successful for inpainting of oils whether or not an invisible repair is required.

HOW ACRYLIC PAINTINGS DETERIORATE WITH TIME

Polymer colours have been in use for about fifty years and have shown few serious defects over that time, if they have been properly applied. The medium does not discolour but some examples give the impression of a faint cloudiness. Fine surface cracking can sometimes be seen when there is very heavy layering, but this does not usually extend far and may be due to poor application, the paint having been applied too slowly. Actual flaking is rare unless the acrylics were applied incorrectly in the first place.

Mechanical damage such as punctures or tears may be found, partly because artists working in the lower price ranges tend to use acrylics, and often paint on low-quality cotton canvases that are easily torn. Any steel or iron (screws, nails, support brackets) used in the framing or support will rust rapidly on contact with acrylic paint and can then cause considerable damage.

HOW ACRYLIC PAINTINGS ARE RESTORED

Not many properly painted, undamaged acrylics will need restoration yet; if repairs *are* necessary they should be easily dealt with. If the painting seems insecure, and losing adhesion to its canvas, this is almost certainly due to the artist having used an oil-primed Gesso canvas, or oil underpainting. As discussed, acrylic does not adhere well if applied over oil colours, and variations in temperature or prolonged damp storage can cause the two paint types to separate. I have actually seen an entire, heavily painted acrylic picture free itself from an extra-oily Gesso ground practically in one piece. The solution is to remove and re-apply the paint film to a new, plain canvas using acrylic medium as the adhesive. When using oils this process is a massive undertaking, however when using thickly-painted acrylics it can be surprisingly easy.

Slashes and holes are dealt with in the same way as demonstrated for oils, with patches or complete lining. Although wax/resin and Beva work well (and are my personal preference), it is certainly possible to use acrylic medium as the adhesive. During lining, the painting face need not be specially covered with paper, because the leathery acrylic is quite resistant to crushing; felt padding is adequate. After spreading the medium, apply pressure between weighted, padded boards until it dries, usually no longer than overnight. Medium that squeezes up through the cuts to the paint surface is best removed with a damp cloth immediately after the first pressure has been applied and before it has dried, but take care not to soak the fresh glue layer or adhesion may be destroyed. Such work must be carried out swiftly and the picture replaced under pressure within a minute or two as the acrylic medium rapidly cures and loses tackiness. Small traces seen after removing the pressure should rub off with the fingertips as its bond to the existing acrylic paint surface will be weaker than that between the canvases.

VARNISH REMOVAL

Acrylic varnish cannot be removed as it will have bonded securely to the paint. This is usually no problem, however, because the varnish does not seem to discolour with age. Where a non-acrylic varnish has been used and has started to darken, its removal is quick and extremely simple. Acrylic is practically immune to common oil and alcohol solvents, and all those recommended for oil restoration can be safely applied.

Inpainting, if required to replace missing paint near damage, can be done by applying a spirit-soluble varnish to the space as a separating layer, followed by gouache colours laid on straight from the tube and coated when dry with the same varnish. The surface of the inpainting will, however, be visibly different from the rest of the painting when viewed in angled light. Of course acrylic can easily be used to make an exact, permanent match, if this is acceptable to the owner. It is better to get the original artist to do such work whenever possible.

EGG TEMPERA PAINTINGS

Very little painting is done these days using the traditional material of eggs. Instead, various tube colours known as 'tempera' are used, a word with several different and ill-defined meanings. In actual fact tempera is simply an emulsion paint that is a mixture of oil and water, so even the recently developed plastic polymer paints such as acrylics could be called tempera. A restorer, however, will usually be dealing with much older tempera paintings, for which the pigments were ground into egg yolk. Yolk contains albumen, a sort of glue, dissolved in water; an oil called egg oil; and an emulsifying chemical. When painted out thinly it forms a tough and water-resistant film. By grinding in the usual paint pigments you achieve an emulsion paint that will dry swiftly, with a full-coloured, almost matt surface. The artist would usually make the paint freshly every day, as it dried rapidly, not to mention going off quickly with the accompanying stench of rotten eggs.

The speed of drying meant that long, slow manipulations could not be done and the strokes of the brush were characteristically short. It was hard to blend them together, so variations in tone and gradation of colour were achieved by cross-hatching methods. Careful planning was therefore needed, and most artists would first apply a pure white Gesso underpainting. On this the details of the picture would be drawn in pencil, sometimes in thin paint. Then the actual colours could be laid in place exactly to plan. Layer could be laid on layer, after only a short drying time. Sometimes glazing was carried out and varnishes applied.

HOW TEMPERA PAINTINGS DETERIORATE WITH TIME

Tempera has rarely been applied to canvas, as the medium is brittle when dry and therefore considered rather more suitable for use on boards. Old boards were often superbly made and finished, and it is these that a restorer is most likely to come across in private hands. Consequently the splitting and shrinkage of wood over time is a major concern in egg tempera restoration. Over the years many paintings have been 'cradled' – supporting frames of wood being applied to correct or prevent splitting and warping – but this is a difficult technique to master and the efforts have sometimes made the troubles worse.

HOW TEMPERA PAINTINGS ARE RESTORED

If the picture is old there is a very simple and safe method of restoration – by a highly skilled specialist at a fully equipped

professional studio! Such paintings may be hundreds of years old and of great historic value. No attempt should be made to correct any defects, regardless of how simple the matter may seem.

More recent tempera paintings may be a different matter, however there can be no certainty as to the precise methods used in the preparation, or indeed as to whether they are true egg tempera at all. In any case it is very unusual for modern egg tempera to be brought in for restoration. I have had only three in many years, all for accidental surface damage. These I have dealt with by inpainting with gouache using only a little diluent, after the damage to the board had been filled. I have therefore not enough practical experience to offer useful advice; I would recommend that a client contact the original artist to carry out such work, if possible.

PASTEL, CHALK AND CHARCOAL DRAWINGS

These three materials are applied in roughly the same way and suffer from much the same forms of deterioration. Their adhesion to the support is based almost entirely on their particles becoming involved with the texture of the support material, usually paper. Viewed under a microscope, paper resembles a very thin bale of straw, the fibres being tangled and matted together. Size has usually been applied when making the paper to enable it to accept watery solutions without them spreading, and one or both surfaces of a paper may have been further treated by chemicals or mechanical rolling to render it suitable for various purposes. Where only one surface has been

Fig 207 A large charcoal drawing of Willie Lott's cottage

treated to render it suitable for painting, this is usually identified by the inclusion of a watermark readable from the treated side of the paper.

PASTEL DRAWINGS

Pastel is practically pure pigment moulded gently into sticks held together very lightly by gum traganth for application. There is therefore almost no medium at all. The pigment particles are dragged off the stick and jam into the texture of the paper as the stick is drawn over the surface. The surface texture of the support paper therefore determines much of the appearance of the initial strokes. Often a coloured paper is used to give an overall colour tone to the work. This is identifiable under the magnifier as the fibres of the paper itself are coloured, which is not the case with pure pastel which is always visible as distinct powdery grains. Pastel artists have also incorporated water-colour by tinting their support paper, either overall or in patches, which again can be identified under magnification, the pigmentation of the water-colour being distinguished from the dense powder of the pastel.

After the main body of dry pastel pigment has been applied, it is customary to work over the surface again, applying the same pigment or different colours. Rubbing the applied pigment with various tools such as rolled up paper sticks called 'touchons', brushes or the bare fingers gradually produces vigorously textured or velvety smooth colours, more intense in actual hue than in any other painting method. The pigment colour is not subdued by any coating of medium, and this produces its characteristic rich appearance.

Application from sticks is only one method of use. Brush work with pastel powder can give the softest, most even and delicate colouring over large areas; dampened brushes dipped in pastel powder can produce intensely sharp and delicate textures; while stirring it into plain water and applying by brush produces effects almost indistinguishable from true water-colour. Pastel is therefore one of the best methods of re-touching and repairing water-colours. Skill in its use is an asset to any restorer.

Though initial underlying strokes may be well held down by the tangled mass of paper fibres, additional pigment is not driven in as deeply and is held comparatively lightly so much of it will fall off. For centuries artists have tried to discover some way of holding these layers in place. Many applied a spray of very thin varnish known as a 'fixative' over their completed work to lightly adhere the particles to the paper and to each other. This does not greatly increase the strength of the bond, however, but simply prevents the pigment falling off its support if it is not shaken. Heavy applications of fixative do give a tighter hold, but the surface appearance is then powerfully changed and may no longer look like pastel.

The fact is that almost all fixing sprays are simply an adhesive medium thinned down, and if you add sufficient weight of medium to work to hold the pigments securely, it coats the particles, dulls their colour and defeats the object. If only the very minimum amount of fix is applied, there is often a lot of loose, unsecured powder about. This makes pastel pictures very fragile and difficult for restorers to deal with.

CHALK DRAWINGS

Chalk is an ancient drawing material, and its handling is virtually identical to that of pas-

tel. A coloured paper is almost universal as a support, either a manufactured colour or a water-colour wash. However, spraying with any fixative is likely to darken its sparkling white. A popular combination is chalk and charcoal and the crispness of this contrast can be dimmed by an incautious, heavy application of fixative. Coloured chalks are available, and red in particular has been used in important works, in many delightful studies by Leonardo da Vinci for example. The paper can then be white, of course.

CHARCOAL DRAWINGS

Charcoal is smouldered wood sticks. These vary greatly in hardness and density of appearance but essentially work like a rather scratchy pastel. Although the medium is largely considered as a sketching tool, in fact very detailed and complex drawings, almost graphic in quality, can be made. A prime use for charcoal has always been the preparation of canvases for oil painting. Traces are sometimes found behind old paint layers, having been used by the artist to sketch out his original design. Large designs for future works are sometimes all that remain of vanished masterpieces. Charcoal can be heavily sprayed with fixative without changing its appearance, and is then fairly easy to handle.

HOW POWDER DRAWINGS DETERIORATE WITH TIME

LOSS OF PIGMENT AND FADING

The main problem of all these 'powder' types of drawing is the actual loss of pig-

ment over the years. When opening up an old pastel from a glazed frame, it is usual to discover pigment lying in the lower rebate of the moulding and a dusting on the inner face of the glass, which is sometimes a dim but unmistakable reproduction of the picture. This reduces the intensity of the image and causes finer details to become blurred. The damage is greatly increased by friction through handling, during framing for example.

Fading due to strong light may also be a problem with coloured pastels, as in water-colours, because the pigments are not sheltered by any surrounding medium. However, since practically all pastel artists have used some form of fixing, you do find patches that have effectively had a medium adhesive. These parts may be held more securely and be less faded, however the original attractive, velvety surface may have been lost.

Chalk and charcoal survive well, possibly because they were often done vigorously, working the powder deeply into the paper texture. Also, it is easier to 'fix' them without damaging their appearance. This does however often lower the brilliant whiteness of new chalk.

DAMAGE TO THE SUPPORT

The support, almost always paper, is the other area in which deterioration may take place. It can suffer all the defects and injuries afflicting water-colours – fungus attack, foxing, tears and abrasions, and increasing acidity. The damage is sometimes slightly less obvious than with water-colours, however, since the layer of powdery pigment may be thick enough to obscure the developing spots of foxing. Checks from the rear of the paper will often reveal them, but take care – turning the paper upside down may cause yet

more pigment to fall off. Lay it on glass and hold it above you with a mirror reflecting light upwards on to its rear face.

HOW POWDER DRAWINGS ARE RESTORED

It is essential to treat powder-type paintings with exceptional care. Store them flat, keep them free from vibration, out of the light and dry. I use a large, specially-made glazed picture frame laid flat on a shelf; its glass is hinged to rise upwards and the frame is deep enough to leave a space above any picture laid within it. A small bag of silica gel dryer is placed inside and the whole thing covered with dark cloth. The combination of a weakly attached pigment and a paper support means that restoration is a difficult and often unsuccessful matter.

TREATING PROBLEMS WITH THE SUPPORT

It is very difficult to treat any powder drawing by immersion in liquid. Treatments must almost always be limited or indirect. Surface marks and adhered particles are corrected by dry methods, particularly the use of scalpels to lift the material away.

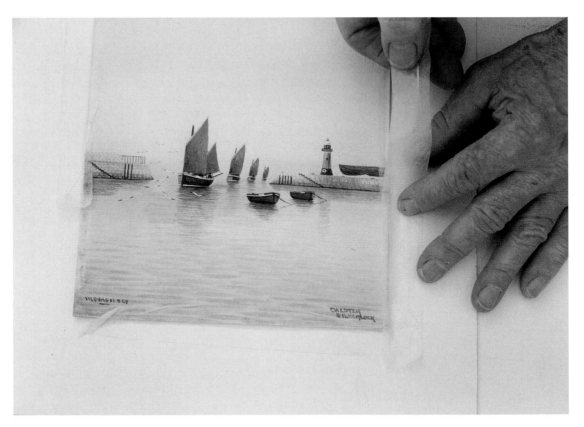

Fig 208 Pictures unsuitable for immersion can be taped temporarily to a support mount (mat) . . .

Fig 209 . . . and treated by spraying upwards from below. Always wear eye protection when spraying bleach.

The job is tedious and demanding but reasonably safe. Another important tool is some form of strong bridging support for the wrist as it works over the picture, which of course must be kept flat at all times.

Tears and similar damage can be treated as for water-colours and prints, but the fragility of the pigment surface will make the work very awkward. Small stains can be treated with spot bleach, such as Chloramine T, applied from below with a brush. This material does not retain much bleaching capacity after it dries, so can be allowed to remain without washing out.

Foxing is a much greater problem unless it is so slight that the individual spots can be treated as above. Complete immersion is difficult and should never be attempted with an important work. However, with less valuable pictures it is not impossible to apply Chloramine T to the back of paper supports from beneath, using a spraying tool, if the work is suspended.

Cut a simple card mount with its hole an inch smaller than the picture, and tape the work to it, face-up, with thin conservation tape which can be easily removed.

Then use a fine sprayer to direct very dilute Chloramine T upwards to the rear of the support. Wear protective goggles. Keep the paper supported in a draught of air while drying. The paper must not be too thin, or the weight of the spray itself could make it sag and tear. For more delicate

paper try taping the work pigment-side-down on a clean glass sheet, then gently turn the glass over without jarring. Spray it with Chloramine T from a distance, allowing it to fall gently on the back of the picture. You can observe the progress of the bleaching through the glass. In neither method can you stop the process once started; the bleach has to run its course until it dries.

It may sometimes be necessary, after consultation with the owner, to treat the work with a fixative spray of greater than usual strength, even though this dims or damages the surface, because it is a lesser evil than some serious problem, such as advanced foxing, being left untreated. In these cases I have found that thoroughly fix-sprayed charcoal pictures and pastels that have already shed their initial loose surface can be gently immersed in weak bleach and wash water. First fit a drain tube to the base of a flat tray and fill this with bleach to a depth of 5mm (¼in). Place the dry work flat on a supporting glass and lower it slowly into the liquid. The paper will float on the surface at first but will gradually absorb bleach from the back and sink down. This method will reduce the risk of disturbing the picture's surface pigment with a surge of water if it were simply plunged in, or the liquids poured directly on top. Do not tilt or swirl the dish, as is usual with most immersion techniques. After an estimated time of bleaching, or a visual check of its progress, open the drain and pour the bleach away. If considered essential, a similar wash in plain water can be done, though if Chloramine T has been used I believe it would be safer to leave it unwashed. Leave the work to dry in the draining tray without any movement at all; this will permit the resettlement of any freed pigments. When completely dry, which may take more than a day, inspect the work for loosened pigment and, if desired, give a final spray of fixative.

DEALING WITH MISSING OR DAMAGED DRY PIGMENT

These types of painting are often treated as exceptions to the rule that a different medium from that of the picture itself is used for inpainting. There is no real way to inpaint other than with a powder without the repair being perfectly obvious. Certainly, any attempt to colour missing or damaged parts with, say, water-colour will rapidly lead to greater problems still. One approach is to use a powder method of a different kind or different colour. For example, a charcoal drawing might be inpainted with soft grey pastel, identifiable at close range but not in distant viewing. Losses of coloured pastel might be filled with a grey tone instead of an accurate colour, which again will allow reasonably satisfactory viewing.

However, if patches of pigment, chalk or charcoal are lost or greatly weakened by an accidental identifiable cause such as a scuff mark, it is acceptable to brush-blend the edges inwards to make a repair. This can only be done if there is sufficient adjacent pigment of the correct colour.

DEMONSTRATION 11 – REFRESHING PASTEL PIGMENT ON A PORTRAIT AND PRINT

If insufficient suitable neighbouring pigment exists and if the owners agree, in an exceptional case such as this spill-damaged portrait, you can add exactly matching new pigment.

You need a perforated working shield of thick perspex, raised on supports, to prevent it touching the surface. It may be possible to dampen the exact missing spot with plain water, then to gather matching pastel powder on the tip of a fine, soft brush and work it gently in; or spill or dab

Fig 210 Damaged pastels are very difficult to repair if the paper has been stained, like this one, with varnish or glue.

Fig 211 First, water can be applied to soften the stain a little.

Fig 212 Then pastel of a matching colour rubbed from a pastel stick and applied by dabbing.

Fig 213 Direct spotting with related colours will build up the pigment layer.

Fig 214 Gentle scuffing with a bristle brush can press the powder down into the paper texture.

Fig 215 The result is good but the time spent makes professional work expensive.

Fig 216 The Capel Hemy print had ink losses in places. Like water colours, prints are best recoloured with pastel and applied fixative.

on the pigment needed, blowing away any surplus after it has dried.

Invariably more than one colour will be needed, some being applied directly from a sharpened pastel stick and then carefully used to match the patterned surface of the support paper, sometimes with a rather stiff oil painting bristle brush that has been cut short. Flesh tones are similarly added and a light local fix spray given when the colour is satisfactory. The main attraction of many of these works is in the spontaneous, swift flow and vigorous strokes of the original, which is very difficult indeed to reproduce satisfactorily.

Nonetheless, an artist familiar with the use of powder pigments can often carry out surprisingly effective restoration work of this kind, and pastel is used extensively in water-colour and colour print inpainting.

This Capel Hemy print is obviously not a pastel. It had been cleaned by bleaching, (demonstrated in Chapter 5), but had small, circular clear spots remaining after treatment. As with water-colours, pastel is the safest medium to use for inpainting on prints. It is delicate, easily removed if necessary, yet blends well with the original. With the protective shield in place, pastel was matched to the background sky colour, and powder pastel applied by a soft brush, fixing lightly and drying between touches to allow for colour changes. The fix material is invisible and reasonably permanent behind glass.

— 12 —

PENCIL, COLOUR PENCIL, CRAYON AND OIL PASTEL DRAWINGS

PENCIL AND COLOUR PENCIL DRAWINGS

Pencils are usually filled with smooth, dark grey graphite mixed with a clay, which sticks to a support partly by embedding itself in the paper fibres and partly by adhesion of the material to the surface. The material is practically waterproof and is very long-lasting if properly framed behind glass. Completed work is not usually treated with fixative, but if pencil is lightly applied it may be easily damaged or even removed by rough handling. Obviously pencil can be a sketching medium, but many important works have been produced, and pencil lines are frequently an integral part of the construction of water-colours.

There are varying hardnesses of pencil, the softer types producing a denser, darker line, while hard pencil gives a thinner, accurate line that is often distinctly grey. The hand grip used and pressure exerted can also alter the line quality. A vertical hold gives delicately sharp, parallel-sided, even marks, while a soft pencil held almost flat with the paper surface can give soft, flexible lines of varying width and density. The method of sharpening, to create a point or chisel tip, also influences line width. The distance between the head of

the pencil and the tips of the fingers can affect control and style, making it possible to identify unsigned art works, being the equivalent of the characteristic brush work of painters.

Colour pencils are really a form of wooden-cased coloured crayon and are treated as such. However, their handling resembles that of graphite pencils, with the same flexibility of line. So far as I am aware, few drawings of any significance have been made in this medium. Incidentally, these are quite different from the water-colour pencils described in Chapter 8.

CRAYON AND OIL PASTEL DRAWINGS

Crayons are paper-wrapped wax sticks, coloured by various means, depending on their purpose and quality. Many are made for children's use and may be in quite fugitive colours. Consequently, a crayon picture should not be assumed to be permanent. Application is as with a pencil, with less precision and with rather more rubbing of the waxes into the support surface. Any black in the drawings is best done using a crayon black rather than graphite pencil, which has a different sur-

face appearance and may not blend with the colours.

Oil pastel is a medium similar in handling to the wax crayon, but which has greater adhesive power and different constituents. It is intended to produce a kind of oil painting, usually on paper, and may be overpainted with solvents or oils to make a weak form of paint. The rubbing motion used in its application lends its own characteristic appearance, often linear and scratchy and without the brush marks that are almost universally visible in other oils. In general it does not produce such a fully cured, strong and complete coating as a normal oil paint. I have found it to be mostly used by students.

HOW PENCIL, COLOUR PENCIL, CRAYON AND OIL PASTEL DRAWINGS DETERIORATE WITH TIME

The common factor among this group is that they are almost all made on paper and therefore suffer from the weaknesses of that support, being affected by soiling, foxing and an increase in acidity. These problems are dealt with using treatments similar to those for water-colour.

Of the drawings themselves, pencil drawings remain unchanged for long periods. Beware though; if a soft pencil has been lightly drawn but roughly stored, some delicate marks can be erased or smudged.

Crayons, colour pencils and oil pastels are essentially pigmented waxes and resins of various compositions. The permanence of their colour depends on the quality of the pigments and other materials used, but cannot be relied upon to be as great as normal oil paint. They usually grip the surface of the support reasonably well, though the pigmented layer is never as sound or coherent as paint.

HOW PENCIL, COLOUR PENCIL, CRAYON AND OIL PASTEL DRAWINGS ARE RESTORED

These drawings can usually withstand immersion, so the water-based paper treatments recommended for water-colour will deal with problems such as foxing. Remember, however, that all waxes are dissolved by alcohols, so take care when applying spirit solvents or acetone to remove stains as all of them may damage the original work. Inpainting is difficult, the strokes being almost impossible to match undetectably. As always, do not use the medium of the picture for your inpainting.

For pencil, use thin charcoal. For colour pencil or matt crayon use soft pastel (normal pastel, as against the oil type) or water colour. For glossy, low value crayon or oil pastel use acrylic. For high-value crayon or oil pastel pictures, use soft pastel to water colour, after consulting the owner.

— 13 —

INK DRAWINGS AND PRINTS

INK DRAWINGS

Ink has been used for centuries and in countries such as China and Japan is a major art medium. Traditional carbon ink blocks were ground and mixed with such care that an apprentice might spend several years merely practising the ink production process. Carbon inks do not fade but other inks may depend on colour changes caused by chemical action for their effect; this may be any degree of brown through to black. Such inks are not always secure against fading and some may vanish entirely over time. Modern coloured inks are made by highly technical processes and in various degrees of permanence. Any such work in colour must be approached with care, and treated as if it were a painting until trials have made certain that it will withstand any treatment you intend to employ.

The tools for ink application have traditionally been pens made from various forms of solid material, for example wood, metal and quills, and brushes of various fibres and hairs, including human hair, but not usually bristle. The handling of pens and brushes is an individual matter, and the action of the wrist and fingers, coupled with variations in pressure and speed, make it possible for an expert to distinguish with some certainty the work of any particular artist. The characteristic brush hold for Chinese-style painting is essentially vertical, with the painting action involving the whole arm. Western artists tend to use the conventional 'handwriting' hold mainly controlled by the fingers and wrist. A few handle the brush almost flat to the paper. Restorers should practise the holds to enable them to reproduce the style for inpainting, if required.

The usual support is some form of paper, though almost any flat surface has been used. The paper will be sized, perhaps with gelatine, to prevent the applied ink spreading, and paper makers add various surface coatings to enable different effects to be achieved, especially on very smooth surfaces for detailed work. Precise pictures may first be laid out in soft pencil, of which traces may remain in the work (these should *never* be removed during restoration).

Brushes are the favourite tool for Chinese-style work. These are more varied in size and materials than western water colour brushes. Their handles are often made of bamboo, the bristles may be of almost any type, including human hair, and are not usually set in metal ferrules. Some are bulky but even these are flexible enough to taper smoothly to a long, sharp point. Cheap versions sold in the West are often poor specimens. Naturally, ink can be brushed out as thin paints may be, and an infinite variety of textures produced, including large patches of solid ink. Sometimes stencils and stamps used in conjunction with normal lining can make the work resemble a print. Magnified inspection will reveal the crossing of the applied lines, which are not present in

prints. Occasionally, and again usually in Chinese-style works, water is used to thin the ink down to wash level, producing a range of continuous greys, reminiscent of a monochrome water-colour.

HOW INK DRAWINGS DETERIORATE WITH TIME

Ink drawings on paper suffer all the problems described for water-colours – support discolouration, dirt, acidity, foxing and fungus attack, tears and other physical damage. Whether inks fade, either naturally or under treatment, will depend on their nature. There are thousands of inks on the market, some intended to be permanent to the extreme, others with a maximum life of five years. As with prints, mature black is nearly always secure, but some ink types, originally dark brownish-black, may lighten to pale brown or even yellow in damp or too-light conditions.

HOW INK DRAWINGS ARE RESTORED

Ink restoration is virtually identical to that of water-colours or prints; the same procedures – and the same tests if the drawing is in colour – can be used. Black drawings are nearly always secure against the bleaching chemicals used, but grey or coloured ink drawings may be different, particularly if they appear to have been applied by brush, indeed they may not be ink at all! Combining ink drawings with water-colour is common. Consequently, start by treating coloured ink drawings as though they were delicate water-colours,

and black ink drawings as though they were prints.

PRINTS

Essentially, a print is made by applying wet ink to a carefully shaped, flat surface, then pressing this against a sheet of plain paper. The pattern of ink is transferred, dries almost at once, and you have a print. Prints vary mainly in the way the original ink pattern is made.

WOOD

If you make a smooth-faced block of wood, perhaps using apple or beech, then cut away its surface with knives and chisels to leave a raised pattern, you have a wood-block. Spread ink over the block face and press it on to paper and an ink impression of the raised surface will appear. You have made a wood-block relief print, one of the best known early methods which is still in use today.

METAL

Suppose you use a plate of copper instead of wood. In theory you could still cut away the unwanted metal from the flat surface, leaving the pattern raised, ready to be inked and printed as a relief print (printers' type is a kind of relief print). When creating pictures, however, this would be difficult and take a long time. Instead, a different method of printing is used.

First, cut or scratch your drawing in fine lines on a flat metal surface, perhaps using a traditional sharp gouging tool called a graver. To make your print, spread ink all over the block, rubbing it well into the engraved lines, then wipe the metal surface clean. This leaves the engraved lines

141

full of ink, level with the block face. Finally, dampen a sheet of paper and press it down using very heavy weights or a screw press, or pass it between rollers. The soft paper surface is pushed down the cracks and is marked by the ink lines. You have thus made an engraving. Because the ink is trapped in the sunken parts of the block, it is called an 'intaglio' print.

This obviously requires great skill with the graver to achieve a good result. A different and more flexible way of producing thin lines on a metal plate is to burn them in using strong acid. First, coat the surface of the metal with a resist – any wax or varnish material that resists acid. This may be black, or the surface may be blackened later to make your drawing easier to see. Then, with a pointed or patterned tool, draw on the resist and make bright visible lines. There is no need to scratch the metal itself. Immerse the block in strong acid and this will eat away at the metal wherever you have removed the resist.

The process of eating away is called 'etching', and after you rub ink into the lines of the etched pattern and press it to paper you have a printed etching which is also known as an intaglio print.

STONE

You will need a specially chosen and prepared stone on which you can draw a 'lithograph', litho meaning stone and graph meaning drawing. Draw your picture on the stone using wax crayons, then wet the stone all over. The water will wet the stone but will not stay on the wax drawing. Next apply an oily ink to the stone. This will only stick to the crayon marks. Finally, press or roll the stone on a sheet of paper. The ink pattern (your design) will be transferred to the paper and you have a lithographic print. The stone can be re-inked many times to give multiple, identical prints. There is one problem with this method, however – the print will be a mirror image of your drawing, so you must draw your pictures backwards.

COLOURED PRINTS

You can easily make a coloured print using a coloured ink. Of course, it would then only be a single colour, probably not what you had in mind. Most of us take the term 'coloured print' to mean one printed in several different colours, and this can be done by making two or more separate blocks, each one representing the lines needed in a particular colour. Provided these can be applied to the paper in exactly the same place ('in register', as a printer would say), you will have a simple coloured print.

Relief blocks such as woodcuts can be made in this way, and some old prints have several different inks applied. Not only does this give a wide range of actual ink colour, but where the different inks overlap they produce yet more colours. If several colour blocks are used the result can resemble an original painting. Sometimes a large block, or several smaller blocks, may have each part of the design individually inked in different colours, producing a multi-coloured print in one pressing.

To achieve photographically accurate full colour might appear to require hundreds of different coloured printing inks. This is not the way modern full-colour prints are made, however. Instead, only three coloured inks are used – magenta red, yellow and blue, plus black. When mixed together in the exact proportions, these can produce almost any colour needed. However, they are not actually

mixed at all. Instead, four printings are made, one magenta, one yellow, one blue and one black, all 'in register'. These prints are therefore made up of thousands of tiny dots of pure colour, set in a distinct pattern and not touching each other. So fine is the pattern in high-grade work that the spots are blended together by our eyes and we see them as mixed colours of the precise shades needed. Glance at any colour in a newspaper to see a coarse version of this method.

The four separate dot picture plates are created using photography. Nearly all modern colour prints are made like this, on huge machines at great expense. From a distance, the shades will appear just like the old master that was photographed. A glance through your magnifier will identify a print made in this way, even though it may seem like an original to the naked eye.

HOW PRINTS DETERIORATE WITH TIME

Since prints are mainly made on paper, the problems are very similar to those affecting water-colours and drawings – mould attack, foxing, fading in strong light, and physical damage such as tears and burning. Gradually the strength of the paper declines, becoming more acid and fragile. In general, most prints are made on paper that has been specially treated, and are not of as high quality as those used for original work.

HOW PRINTS ARE RESTORED

Print treatment is a good deal less difficult than for water-colours, if only because they are almost always less valuable and so less worrying to handle! It is worth taking special care not to rub the wet surfaces, as it is often quite easy to remove the thin layer of printer's ink. As you will have seen with your cleaning in Chapter 5, there are even fewer problems with black ink prints, because these are not as susceptible to fading as are coloured ones.

In general you should approach cleaning any print as though it were an original water-colour, because some older inks can be weak. Consequently, follow the appropriate guidelines for water-colour cleaning. In fact, tackling colour prints is good training for cleaning more valuable water-colours. You will find that somewhat swifter, stronger solutions can be used on prints, however, and in the vast majority of cases, prints can be cleaned by either dry or immersion methods. As always with paper, the real risk is tearing the picture when it is wet. If this does happen, do not delay – use the repair methods set out in Chapter 8 before the paper dries out.

INPAINTING

Inpainting refers to the painting in of missing parts of a picture under restoration. It is a subject that has provoked bitter controversy, particularly regarding what should appear in the gaps, a topic I have covered in detail in previous chapters. One of the main 'rules' of professional restoration is that the added work should not become inextricably mingled with the original work; it must always be possible to retrieve the original. Consequently, you will notice I have included no oils in the list of materials you need. This is because as a general rule you do not use the same medium as the original for inpainting. If the inpainting on an oil was also done in oils it might soon become impossible to distinguish, and the better the match, the harder this would be. You would use oils for inpainting only in the unlikely case of inpainting an acrylic original.

MATERIALS

The range of materials needed for inpainting is wide. The main pigments, those that will match nearly every colour encountered during restoration, are: titanium white; black; burnt umber; raw umber; burnt sienna; yellow ochre; cadmium yellow pale; cadmium yellow deep; cadmium red light; alizarin crimson; viridian green; cerulean blue; ultramarine; cobalt blue; and phthalocyanine blue. Although you will only need small tubes of each, the expense is incurred because you may even-

tually need these colours in acrylics, tube water-colours and pastels.

To limit the initial outlay, if you are trying to restore oils, a reduced selection of acrylics and tube water-colours for landscape restoration might include titanium white; black; burnt umber; burnt sienna; yellow ochre; alizarin crimson; cerulean blue and ultramarine. If you are restoring water-colours or prints, choose deeply coloured pastels of the same pigments, and use plenty of white to lighten their tones as required.

To apply water-colours, use high-quality water-colour brushes, preferably genuine Kolinski sables. At first, get several size three rounds and one about 3mm wide flat. For other work, polyester brushes of the same size will serve, especially for acrylics, a medium that is very hard on brushes. Apply pastels with small soft brushes, size four or five, preferably of sable, which seem to pick up pastel powder easier than man-made fibre.

In addition you will need a small hairdryer, a rigid easel which can be adjusted from flat to vertical, some improvised wooden rests against which you can steady your hands, and an inexhaustible supply of patience! Most importantly, if using acrylics for inpainting, you will need a special non-dry palette.

This palette keeps acrylics moist, and is an essential tool for a restorer because the work is slow. It takes time to apply the paint carefully and precisely, and if acrylic is exposed to the air for too long it will dry up.

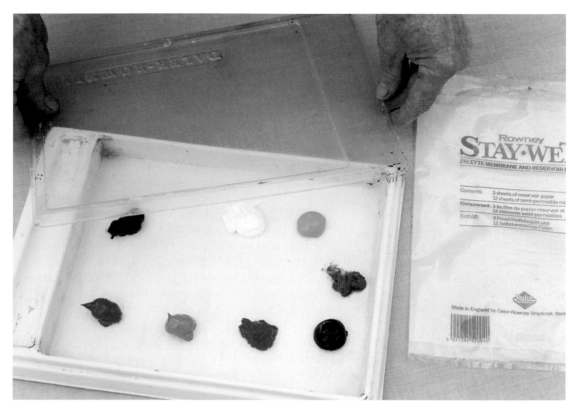

Fig 217 A patent Stay-Wet palette is a good investment for acrylic users. It keeps paint workable for hours.

You can, of course, buy all these materials from artists' suppliers, but you may find it difficult to obtain some of the restoration chemicals and adhesive mentioned. If this is the case, telephone your nearest technical college, art college or university, asking for the names of local chemical suppliers.

EQUIPPING A WORKPLACE

Even if you are just starting out in restoration you will need a place to work. If you are keen, quite long periods of concentrated effort will be necessary and you must therefore have uninterrupted use of the space, not the easiest thing to achieve.

What sort of space, and how much, depends on the type of work you intend to do. If your interest is in works on paper, whether prints, water-colours or drawings, you will need easy access to water, not necessarily running water, though that would be best, but supplies that you can easily replenish and in addition (easily forgotten in planning), a place to pour away the waste.

Problem pictures on paper will need immersing in several liquids, which thus leads us to the issue of space. You will need enough flat table space (with a waterproof surface) at standing height, to accommodate two water trays, each four inches larger than the biggest pictures you will handle; prints and drawings can be very large indeed. An uninterrupted stretch of work top is ideal so that the trays can be side by side, enabling swift transfer of work from one to the other. Waste liquids can be drained off into pails. For non-immersion work and final re-touching, you will need dry table space with an easy-clean surface, perhaps at a lower level, and with room for an easel.

Ventilation is certainly necessary, not only for personal comfort but to speed up the evaporation of liquids on the work.

Access to good light is also required. Sunlight is pleasant to work in but tends to be variable in intensity. When inspecting the progress of work, it is often necessary to view the paper by holding it up to the light. For these purposes a north window is ideal, or alternatively an array of fluorescent tubes. If you have the chance, mount three such tubes on the wall behind your workbench so that you can swiftly draw the work from a liquid and look straight through it, still held over its tray. This is much more comfortable than looking at it through a roof-suspended light. Also, the liquids do not fall off on your face!

Do not forget that the pictures themselves will require a secure place of storage. If you choose to take up picture restoration professionally, this will become more important as the value of the works rises. Personally, I never store any work of value in my home or studio for more than one night, but have an arrangement to keep the work elsewhere with full security. Contact your home insurance company to discuss possible cover against loss.

SAFETY AT WORK

While the methods I describe make little use of dangerous, powerful bleaches or other chemicals, inflammable (explosive) liquids and few procedures that give off toxic fumes or unpleasant smells, the issue of safety must be taken seriously for the sake of those around you. In particular, watch out for places where children could

reach even the basic materials. The use of white spirit is so common, for example, that we forget that babies can die just by drinking a mouthful of it. Methylated spirit is also a powerful intoxicant, while acetone gives off strong fumes and ammonia can injure the eyes. Keep all of these well stoppered. Decant enough from your larger stocks into small containers for daily use on your bench. A lockable cabinet is also essential. It will need to be fairly large to accommodate not only fresh supplies but also prepared liquids, possibly two gallons or more, that you are saving for later use.

Be aware of the positions of electric power points. Spilling water on these can result in electric shocks and they should therefore not be situated near your 'wet' workbench.

Safety masks can be uncomfortable, but they must be used to prevent strong chemical droplets getting into your throat and lungs. Surgical or domestic rubber gloves protect your skin against many chemicals, and are particularly important if you are sensitive or allergic to them (cotton gloves protect your work rather than your skin).

Always have a fire extinguisher of the correct type (carbon dioxide) near the room door.

Restoration is not a particularly hazardous operation. You probably will not need splints and slings, but do keep a small first aid kit handy as razor knives and scalpels are used and can sometimes slip.

CARING FOR PICTURES

Some years ago I was called to inspect a large oil painting by a famous English artist. It had fallen off the wall, its frame was shattered and its paintwork damaged. The reason was obvious, even to the embarrassed owner; for years this heavy, very valuable picture had been suspended on two lengths of cheap straw-bale binder string. Even if an old picture hanger is made of wire it will probably be of several strands, tending to weaken where it passes over the wall hook. It may also fray around the screw rings where it is tied on to the frame. It will hang on until perhaps a single strand remains, then I will receive another call!

Nylon cord is much tougher, almost unbreakable, although this too will gradually stretch with time. In this case the picture will warn of the problem by sinking lower and lower on the wall long before the cord actually breaks. However, knots in nylon have a habit of slipping gradually undone. For safety, always fasten back the free ends of the cord or wire with thin twine, sewing thread or electricians' PVC adhesive tape. (Do not use the clear cellulose adhesive tapes; they dry out and peel away fairly quickly.)

Another common cause of disaster is failure of the wall hook on which the picture hangs. Often this is far too weak for the weight of the picture; I have seen paintings that took two men to lift hanging from a single nail driven into weak plaster. To establish an idea of what is needed, take a medium-sized picture with glass, and lift it by the middle of its cord with the tip of your outstretched middle finger (do this over a settee or other soft landing area in case of accidents). You will be amazed at the strain on your finger, yet that is what has to be borne for years by the wall hook. For all but the smallest of pictures, follow the golden rule – one hook good, two hooks better. If you have two wall hooks spaced three-quarters of the picture length apart, this will not only save the picture if one of them gives way, but it will also make the picture easier to adjust and keep level.

Remember too that the weight a hook can carry also depends on the strength of the wall. Older houses may have very weak lath and plaster behind the wallpaper, while modern houses may have walls covered with thin sheet plasterboard. There are various forms of strong wall fixings, some thrust into drilled holes, others with various forms of gripping or locking devices. Pictures last more than one lifetime so it pays to give them adequate hangers.

Thousands of pictures have been damaged or destroyed in accidents such as these. Check yours at least every year to prevent it happening to you.

(1) See that the screw rings in the back of the picture frame are sound and strong enough for the job. If they seem rusted or in any way suspect, replace them. Framers carry various types in stock and will advise on suitable sizes. Do not put new rings into the old holes, but screw them in about

25mm (1in) above or below the old holes. Ring holes can be places of weakness in frames.

(2) Test your wall-hooks. If any can be moved, even slightly, get them fixed or replaced. In case of doubt ask a keen DIY friend to look at them.

(3) Look at the hanger cords and wires. Are they sound and free from any trace of fraying? Is domestic string used? Note how much new cord or wire you will need, adding 100mm (4in) extra for each picture for use in the knots.

(4) Obtain a supply of framers' picture wire and cord. This is available in varying thicknesses, and any framer will advise you

of the thickness required. Heavy pictures may need two or more lengths, tightly twisted or plaited together. Also buy a length of flexible transparent plastic tubing, large enough to slip over the cord; this is available from DIY stores, garden centres or electrical suppliers. Use 150mm (6in) for each picture, to protect the wire or cord at the point at which it passes over the support hook.

Note Always replace the whole length of any broken or fraying wires. Never simply twist old, frayed wire together again; it is often quite fragile and if it has already broken in one place it may well do so again in another. For the highest quality work and

Fig 218 Important pictures should have two hanger cords, a metal one for principal use, and a nylon cord as reserve, each on separate hooks.

Fig 219 Plastic tubing at the wall hook positions saves wear on hanger cords.

maximum safety, I usually fix a brass wire as the main support, and also use a separate nylon cord, with its own hooks, to act as a reserve safety cord if the neglected brass wire should ever fail, as it inevitably will.

When re-hanging a picture with wire, fasten one end first. Make two full turns through the hanger ring and twist 80mm (3in) or so of the wire tightly back around itself to prevent it from slipping.

Slip two 80mm (3in) lengths of the transparent plastic tubing over the wire to rest where the wire will pass over the hooks; this will at least double its life. Then try the picture on its two wall-hooks and find the precise length of wire needed. Lift the picture cautiously down and

lock the second end securely in place. Re-hang it with the protective tubes resting on the wall hooks.

While working on a painting you can improve its conservation by several simple means. Most deterioration arises from dirt, damp and excessive light. Keeping these at bay need not be expensive.

BACK PROTECTION

Paintings that have had their backs covered by carefully applied board are always in much better condition than those with open backs. Simply cover the back of the frame with plain card, obtainable from art

shops, staple and tape it into place. Transfer any details written on the back of the painting to the outer face of the card, for ready reference without dismantling the picture.

VENTILATION

Cut a hole about 75mm (3in) wide and 50mm (2in) high in the lower half of the back, clear of the frame, to allow the passage of air to the interior. Cover this with a loose flap of porous paper or thin cloth to keep dust and insects at bay.

DAMP PROTECTION

Just inside the flap, where it can be reached from time to time for drying, tape in place a sachet of silica-gel drying crystals. Also, fasten cork, wood or foam wedges behind both lower corners of the frame to hold the frame's lower edge clear of the wall. This will prevent the trapping of damp air and allow free circulation to keep the picture dry, even on slightly damp walls.

Keep all valuable pictures out of direct sunlight and away from strong heat. A traditional place for the family portrait is above a fireplace, and this tradition creates a lot of work for a restorer! Watch frames for woodworm: they also love paper. Remove the pictures from its frame before applying proprietary killer. Picture mites can attack canvas too, and dealing with them in oils is simplest done by drying out the canvas thoroughly, then exposing both sides of it for several hours to direct sunlight. Most mites will die of the heat. Finally, and most importantly, inspect your pictures every year at least, taking them off the wall to do so. Cast your new, professional eye over them; a problem caught early is a problem halved.

— 17 —

FRAMES

Very few picture frames have any significant financial value. Quite often clients will ask me to restore ornate gilt-looking frames. I usually have to point out to them that the frame is either modern and factory produced, is a rather earlier frame in poor imitation gold leaf, or is an ornate older frame whose elaborate carvings are in fact plaster casts with silver leaf covering, lacquered over in yellow to simulate gold. Sometimes they are indeed real gold leaf, but are worn and scratched. Financially speaking, the majority of these examples should only be professionally restored if they are definitely associated with a painting by a noted artist. As frames alone, they simply would not merit the expense.

A genuine antique, hand-carved wood frame, whether gilded or not, that is in good condition is one example of a frame that *is* valuable, indeed if you come across one of these, do not set about restoring it; instead, offer it for sale at a major auction house. Any restoration you attempt is likely to be perfectly obvious to the skilled eye

of a buyer and may drastically reduce the value of the frame.

Restoring modern frames is surprisingly difficult. To repair a clean-lined, smoothly finished, plastic-coated frame so that the work is invisible is for practical purposes impossible as the surface will show every little mark. However, there are a few wooden and reproduction-type frames of more complicated, old-fashioned appearance that offer some hope. If the frame material finish is irregular, with artificial 'distressing' to make it look worn, minor inpainting repairs can be unobtrusive and become lost in the complex surface pattern. It would, however, be simpler and more effective to buy a length of similar, high-quality new moulding from a framing shop, and spend your time and effort on learning how to produce your own, professional standard frames. This certainly can be done at home, and there are many books available on framing techniques that offer an introduction to this interesting, artistic and highly skilled field.

RESTORING PICTURES FOR OTHER PEOPLE

Once you start restoring pictures of your own it will not be long before friends ask you to work on their problem pictures. This is an important moment for you. With your own pictures, any mistake or damage caused by inexperience will only affect you personally and can be dealt with by a shrug or possibly by furtive concealment of the result. When the picture belongs to someone else the position is very different. It would be all too easy to destroy a long-standing friendship through some misfortune with a favourite picture brought to you, even if you made no charge. Worse still, if you did make a charge, even by way of receiving some service in return, the matter could become very serious as you might find yourself legally liable for any loss of value.

The problem is that the financial value of a picture may be much more than either you or its owner realize. As I noted earlier, it is impossible even for experts to be certain of a valuation, though some of them get close by specializing in a narrow field, for example Victorian portraits or nineteenth-century prints. Even so, they will never guarantee their estimate. The only reliable way of finding the value of something is to sell it in an auction.

You must start proceedings as if you were already a professional. Explain the problem to your friends (or show them this book!) and if they still want you to try, write out an instruction for them to sign.

The words can be quite simple if you are not making a charge for the work.

(DATE)
To (YOUR NAME),
We would like you to attempt to clean or repair our picture of (INSERT DESCRIPTION) believed to be by (INSERT ARTIST IF KNOWN). We appreciate that you will do this solely as a friend without charge and we acknowledge that you have told us that you are not a fully trained restorer, and accept that any work done shall be entirely at our risk.
(SIGNED BY OWNER)

You may think that this is going a bit far, however I assure you that it is not only a sound precaution but shows that you take your work seriously and may induce them to get a valuation from an auction house before you start. Remember, it is much harder to obtain a true valuation of a painting once it has been cleaned badly or damaged, if any dispute should arise.

PAYMENT FOR YOUR WORK

If you are to be paid for the work, however small the amount, it becomes a much more important matter. If you offer a service of any kind for payment, you are in

effect legally saying that you are a competent tradesperson on whose skill the customer can rely. People taking cars to a garage for repair are entitled to expect a proprietor to be more than just an amateur mechanic. They rely upon his expertise, and if he makes a mess of the work they can claim damages. Bearing in mind that a picture may be worth far more than a luxury car, you can see the risks you run by casually taking on a cleaning job.

RESTORATION AS A SIDELINE TO FRAMING

Many picture framers are asked about restoration work by their customers, and quite a few are tempted to try their hand at it on a regular basis. This is perfectly legitimate, and over the years framers often attain a high degree of practical skill. The risk may seem small, for only rarely will a picture of real value turn up. However, when it does, it may not be recognized, and this can cause real trouble, and possibly financial ruin. I recall a small painting that arrived at my studio in a most casual manner, whose owners were astounded when it was later valued at many thousands of pounds. My worry was that I had not realized its value, despite years of experience at painting and professional restoration. I was saved from a possible problem simply because, as a routine part of my work, I had recommended in writing that a valuation be obtained prior to restoration. This is a good habit for anyone thinking of entering this business. Incidentally, it is always best to have everything in writing, for if a dispute should arise it will usually be because the sums of money are large, and memories selective!

You should display a clearly written notice in your workshop or studio that is easily visible to potential clients and says something along the lines of:

INSURANCE AND DAMAGE
OUR LIABILITY FOR LOSS OR DAMAGE TO WORK LEFT IN OUR CARE IS LIMITED TO FIFTY POUNDS PER PICTURE, AS SET OUT IN OUR TERMS.

Each customer should also be given a receipt outlining the terms.

TERMS OF BUSINESS

VALUATION
We are not valuers of pictures. We recommend that an independent valuation be obtained before work commences. This may be done through a major auction house, usually with a small or no charge, and we can do this on your behalf if you wish.

Please note that, due to the high value of some pictures, all works left in our care are and remain at the entire risk of the customer. Basic home insurance will often cover the risks when a picture is being framed or repaired, provided the insurance company is notified beforehand. We recommend that, if you feel that the value of the picture warrants it, you should telephone your insurance agent (from these premises if you wish), before leaving the work with us.

It is of course quite impossible for any repair to return a picture exactly to its original form. There are many methods used professionally to treat damage, and we will select those that we consider most appropriate. Some processes call for techniques and materials that can injure paintings in certain circumstances, and while we will take due care, it is impossible to eliminate entirely the risk of damage.

Note particularly that although reasonable care will be taken with your pictures, in every case our maximum liability for any loss or damage, however caused, including but not limited to theft, technical errors, accident or negligence, is limited to FIFTY POUNDS STERLING per picture. Leaving any work in our charge is an acceptance of this limit.

INSURANCE FOR PROFESSIONALS

Although it may seem that the document described will give you adequate protection against paying large sums in damages to a customer, it does not mean that you can ignore the question of insuring yourself and your business against such claims. The cost of defending a case in court, or of an agreed settlement, can be enormous, and it may prove impossible to get these paid, even if you win. If you are insured, the insurance company will not only settle any legitimate claims, but will take upon themselves the trouble of setting up any defence and conducting the case, which can be very time-consuming. It pays to find a specialist company used to providing such insurance in combination with the usual and legally necessary insurance against public liability.

DEALING WITH CLIENTS

When dealing with a client, especially for the first time, be wary of seeming to offer an opinion on valuation by suggesting that 'restoration is certainly worthwhile for a painting like this', for example. Some clients greatly undervalue their property, but others have absurdly inflated ideas, imagining that a modest oil painting is really a Constable! It is far better to deal initially with the practical means of making any necessary repairs. These are of varying degrees of difficulty and cost, as you can explain. Take the simple line that a picture has a personal value to its owners which only they can assess. The cost of cleaning may be worthwhile if it makes the picture last longer or pleases them more, even where its financial value is low. On the other hand, you should also make it clear that a very high professional valuation, if obtained, may warrant providing costly, specialist forms of restoration work, totalling far more than would be spent purely for personal pleasure. This is another reason why a preliminary valuation is so desirable.

Be frank with your clients. No-one is a complete expert on every type and period of painting, so you need not try to be. Admit what you do not know, but say you will find out. Advise them to take expert advice regarding a valuation. Offer them a chance to take the work away for a second opinion. Tell them what happens if something goes wrong and what you can do about it. In this way, clients will become confident in you and remain with you for years. It is largely through personal reputation that restorers succeed, and such honesty should go hand in hand with increasing skill. Then, in time, when you express an opinion, it will be given the respect due to a professional adviser.

THE FUTURE

There is a great deal more to be learned and practised in the field of picture restoration in the future. Even after fifty years of painting, half of them in active restoration work, I have been unable to

learn all that I would like to know. Every year there are new developments in materials and techniques, and much of what I do is being altered as more knowledge is gained. By the time this book is published, new studies will be appearing and being transformed into improved methods. That is as it should be. As a basis for all this new research, you do need the fundamental, practical skills that I have described.

Whether your aim is to become a top rank professional in a great museum, a skilled independent restorer, or a lover of art and craftsmanship working for your own pleasure and that of your friends, you will still need confidence in practical picture restoration. I have tried to pass on some of that knowledge; only you can determine whether I have succeeded.

INDEX